CURIOSITIES OF
YORK

ED & DAVID BRANDON

AMBERLEY

First published 2011

Amberley Publishing
Cirencester Road, Chalford,
Stroud, Gloucestershire GL6 8PE

www.amberleybooks.com

British Library Cataloguing in Publication Data.
A catalogue record for this book is available from the British Library.

ISBN 978-1-84868-399-0

Typesetting and Origination by Amberley Publishing.
Printed in Great Britain.

Contents

List of Illustrations

York – An Outline History

Ancient Times

York stands at the confluence of the Ouse and Foss rivers in a district that is flat and fertile. The Ouse drains a large area of high ground to the north-west of York and the heavy rains that fall there all too frequently manifest themselves as city floods. These rivers provided York with access to the West Riding and to the sea. As late as the 1750s, the Ouse was tidal a few miles upstream from York, which was an inland port of some significance in spite of being 80 miles from the sea. Materials and provisions arrived by boat and the products of its industries used to leave it in the same way. The rivers provided food in the forms of fish and fowl. Along with the Foss, the Ouse performed some of the functions of a defensive moat. It was a source of drinking water and a dump for the town's refuse. Now the riverside of the Ouse where it passes through York is a major attraction. Additionally, York's position in easy terrain east of the Pennine massif meant that it was close to (although not on) the Great North Road. It stood at a natural dividing point between southern and northern England. Later it became a key point on the East Coast Main Line between London, Newcastle and Scotland. York has always been a transport hub.

To the west are the Pennines, which consist of Carboniferous limestone, coal measures and tough millstone grit. Away to the north-east are the North Yorkshire Moors of oolitic limestone and to the east stand the Wolds, composed of chalk of the Cretaceous period. Closer to York in a north-easterly direction are the low-lying Howardian Hills of Jurassic limestone and to the west there is a belt of undulating land around Tadcaster that yields magnesian limestone of a high quality ideal for building purposes. This stone was brought in by river and was used in the Minster and many other churches and major buildings in the city. The Vale of York itself consists of clays and gravels deposited by retreating glaciers. The dense woodland with which much of the surrounding countryside was once covered provided timber for many of York's ancient buildings.

It may well be that our most ancient ancestors spurned the York area as a place for settlement. The woody and marshy terrain of the time probably held few attractions. However, it is known that the area was controlled by the Brigantes, a loose confederation of tribes of Celtic origin who controlled the North of England in the first century AD. It is generally thought that permanent settlement on the site of what became York

began between 1,900 and 2,000 years ago. The Romans called the Iron Age settlement they apparently found 'Eboracum'. The Roman Ninth Legion invaded and fought the Brigantes, who gave a good account of themselves but could not match the efficiency of the interloper's military machine. In the course of the campaign the Romans developed a base for their operations with a fortress close to the confluence of the Ouse and the Foss. York became the headquarters of the Roman Ninth Legion, which arrived around AD 71. It was later replaced by the Sixth Legion, by which time York had developed into a sophisticated military base occupying a sizeable part of today's city centre. This had four gates, one of which was where Bootham Bar now stands, and from these gates main roads went roughly in the direction of the four cardinal points. The headquarters were close to or actually under the present Minster. As often happened, the presence of several thousand soldiers meant that a town serving their needs developed, in this case on the southern side of the Ouse. There would have been many businesses providing a range of services – including those of the sort that would put a little bloom back into the cheeks of a legionary soldier resenting his posting to this bleak and far-flung outpost of the Roman Empire. It is likely that the town, which had defensive walls, would also have housed slaves.

The Romans occupied York for over 300 years and during that time it became a major administrative, ecclesiastical and regional centre. In fact it was the capital of the northern of the two provinces into which the Romans divided England. However, at least above ground, not much remains to be seen in York for the devotee of things Roman. *In situ* are the Multangular Tower (*q.v.*) and a section of Roman wall near Monk Bar (*q.v.*) However, much evidence of Roman York has been dug up, analysed and interpreted and put on display in the Yorkshire Museum, and this material manages to recreate a sense of how life would have been in York when the Romans were in charge. For those eager to pursue oddities, a visit to the space under the Roman Bath pub in St Sampson's Square (*q.v.*) will reveal the remains of a Roman bath. The pub is unique in being the only pub to have a genuine Roman bath in its basement.

After the Romans, Before the Normans

When the authors were at school, they and other unwilling students of history were given the impression that when the very sophisticated and civilised Romans rushed off to defend their empire in the first decade of the fifth century, savage, uncouth, hairy barbarians took over and the hiatus known as the Dark Ages descended like a pall on these islands. It was made to sound like a clean break, but an entirely retrograde one. In fact, many of those who remained behind were of mixed Romano-British stock and the culture inevitably had within it many elements that reflected that mix. The Romans kept detailed written records of their activities, as befitted a regime developing marked bureaucratic tendencies, but after their time the historical records are less complete. New raiders and invaders appeared, but it was a long time before the Anglo-Saxons could impose their writ through most of England, let alone the Celtic fringes. The process probably took about 150 years, by which time many Anglo-Saxons had gone native and developed a distinctive – yet hybrid – culture of their own. The Britons had resisted the intruders, but had not helped their cause by engaging in internecine tribal wrangles and wars.

York continued to be a place of major importance in the seventh, eighth and ninth centuries. It was, in effect, the capital of the Kingdom of Northumbria. During the reign of King Edwin (616–32), who converted to Christianity, followed by many of his subjects, York gained its first bishop and also a cathedral, the exact location of which is uncertain. It would probably have been little more than a crude timber affair. Considerable commerce and trade took place, a port was in operation, and St Peter's School had been established in 627. From 735, York was the seat of an archbishop, by which time it was recognised as a place of learning. Very little is known about the layout of the town or its buildings at this time. A majority of the buildings would have been timber-framed and therefore particularly vulnerable to fires, of which York certainly had several. Sophisticated trading arrangements were taking place. Items such as millstones, imported from Germany, have been found.

In 866, Norse raiders and invaders attacked and captured York and massacred many of its inhabitants, and soon afterwards a Danish kingdom was established, followed by a Norse one, with York as its capital under the name of 'Jorvik'. This regime lasted until 954, when the Vikings were driven out. The Vikings (the name simply means 'pirates'), were by no means just swashbuckling gung-ho men with horned helmets, huge battleaxes and a propensity for rape and rapine. While they maintained their maritime trading interests, they also turned their hand to farming. During this period, the Saxon and the Scandinavian cultures intermixed and left a permanent impression on the locality – the place names and street names, for example. The 'gate', which is such a feature of street names in the centre of York, and the 'thorpe', so characteristic of many settlements in the hinterland, are evidence of the Danish influence in the district. More 'settled' times are suggested by the growing economic prosperity. There is a lack of major archaeological evidence from York during this period, but in the suburb of Bishophill, south of the river, the church of St Mary Bishophill Junior displays a fine tower of the late tenth or early eleventh century. A castle known as Earlsburh was certainly built on the north side of the river in the vicinity of the later St Mary's Abbey.

Although England evolved to become a kingdom ruled from Winchester, this was greatly resented in the northern province of Northumbria and in 1065 the local people drove out the hated Tostig Godwinson, a local ruler imposed from the south who was totally corrupt and incompetent. He did not take this lying down and jointly with Harold Hardrada, the King of Norway, he invaded Northumbria and inflicted a severe defeat on the Anglo-Saxons at Fulford in September 1066. King Harold II then hurried north and with the help of his crack troops, known as 'housecarls', he annihilated the invaders five days later at Stamford Bridge. Tostig and Hardrada were both killed. Shortly afterwards, the Normans landed on the Sussex coast and defeated and killed Harold at the Battle of Hastings. This of course was one of the most seminal dates in English history.

Early Medieval York

England's indigenous population did not welcome the Normans and William I had to go to considerable lengths to impose his will on the truculent and resentful natives. As any

northerner will tell you, it was inevitable that the more serious opposition to William was to be found in the North of England. An uprising in 1068 was brutally put down, after which William ordered a castle to be built at York. A more serious uprising took place early in 1069 and was suppressed with even greater brutality, after which a second castle was built. Even then, the local people refused to accept William's writ and when a Danish fleet sailed up the Ouse, the citizenry assisted in the siege of the castles. Much of the city was burnt, but the castles were taken and the Norman occupants were put to the sword. William was absolutely enraged and came himself to extract a frightful levy of people and property – a 'scorched earth' campaign involving murder and destruction across the North of England. It was known as 'the Harrying of the North'. This seems to have impressed the locals sufficiently for them to stop offering armed resistance and largely fall back on dumb insolence. The castles were repaired. These stood on either side of the Ouse and were supposed to prevent attackers approaching from downstream. The tree-covered motte of that on the south bank survives. The motte of the main castle also survives, but the building topping it, Clifford's Tower, is of the thirteenth century – it is one of the most photographed of York's attractions. The castle on the main site would have been a formidable fortress, with extensive defensive works including what was known as the King's Fishpool, a large artificial lake in what is now the Layerthorpe area.

William then proceeded to appoint Normans to all the major positions of power, and slowly and uncomfortably life began to settle down and prosperity returned. By the middle of the twelfth century, York was probably a more significant city than any other in England except London, Winchester and Lincoln. The rebuilding of the Minster on a massive scale began in 1080. Senior churchmen such as archbishops may have been men of the cloth, but they were also men of the sword, as Archbishop Thurstan of York showed in 1138 when he gathered an army and gave an invading force of Scots a frightful drubbing at Northallerton.

No sooner was York making up for lost time than it suffered a devastating fire in 1137. This caused massive destruction among the city's buildings, most of which were of thatch and timber. The Minster itself was badly damaged. Nothing daunted, a repair programme was put into effect very quickly while many parish churches, monastic buildings and other religious foundations were established – clear evidence of York's growing importance in spite of the fire. The city had no fewer than forty-five parish churches, forty of which survive, at least in some form. The Hospital of St Leonard catered for 500 indigent inmates while the nearby Abbey of St Mary was a major house of the Benedictine Order. York benefited by the canonisation of the markedly less-than-saintly Archbishop Fitzherbert in 1226. Many miracles were ascribed to him and a collection of relics was accumulated. To view this collection of items, gullible pilgrims parted with their hard-earned pennies – but they also spent money on the goods and services that York had to offer, thereby generating income for other layers of the local citizenry.

A well-to-do merchant-and-craftsman class began to emerge and organise itself through the medium of guilds and to obtain trading charters and other privileges from the Crown in return for money. In 1213 the burghers of York bought the right to appoint a mayor and enjoy many of the advantages that went with possessing a considerable degree of autonomy. These burghers later evolved into a full-blooded corporation, and as might be

expected several dynasties came to dominate the city, most making their money from import and export and from property deals. *Plus ça change*! Flemish immigrants were among those who became leading citizens. The city walls and the present Minster, begun in the thirteenth century, are both evidence of the affluence and importance of York as a market, trading, ecclesiastical, military and administrative centre. The population of York in 1300 was probably between 10,000 and 15,000, a very substantial one by the standards of the time.

Some would say that money corrupts everything it touches. Usury was forbidden by the Church, which meant that Jews became the moneylenders. Few people like moneylenders and in 1190 anti-Jewish hatred sparked riots, which became a pogrom so violent that many Jews committed suicide while large numbers of others were massacred. This was in the reign of King Richard I and, while anti-Jewish atrocities occurred elsewhere, these were the worst in England. Many debtors were able to get rid of their debts as a result; they were hardly disinterested observers of the murderous mayhem. Subsequent, more able monarchs discouraged anti-Jewish activity and instead forced the moneylenders into playing the role of milch cow. They taxed them heavily and to such an extent that the Jews eventually became impoverished. When they were no longer able to serve any useful purpose so far as the Crown was concerned, they were expelled from the kingdom in 1290. The former Jubbergate, now Market Street, was named after the local Jewish community.

Being a provincial centre of great importance, York had a habit of finding itself at the centre of things. Its strategic position at just about the southernmost extent of the invading Scots' depredations during the many outbreaks of hostilities with England meant that for about forty years the garrison was considerably strengthened. Various national governmental and legal institutions were based in the city; in effect, between 1296 and 1337, it was taking on some of the work of a national capital. Sittings of what passed for a parliament were held in York on a number of occasions. This kind of activity brought prosperity to York. The population, both within the walls and in the developing extramural suburbs, was growing. The Minster sometimes housed royal weddings. An inglorious episode occurred in 1319 when a Scottish army invaded England and clearly intended to take York. William Melton, the archbishop, no doubt mindful of the activity of his warlike predecessor, Archbishop Thurston, gathered a somewhat makeshift army and sallied forth to do battle. Among his 'soldiers' were many priests and when they engaged the Scots at Myton-on-Swale, north of York, the outcome was a quick and decisive victory for the invading Scots. For whatever reason, the clergy took some of the Minster's priceless treasures with them and these were lost. It is not clear whether the priests had been armed only with the Bible and the Word of God, but presumably these did not make very good weapons, because they were slaughtered in their hundreds.

The general picture, however, is one of York on the ascendancy. At the same time, it was a typically cramped, pestilential, stinking and filthy medieval city, with pigs, feral dogs and rats openly rooting through the heaps of animal and human excrement and general refuse that lay in the streets. Some of the vernacular housing dating from that time can still be seen. A good example is Lady Row in Goodramgate, built around 1320.

York in Late Medieval Times

York enjoyed prosperous times during most of the period from 1350 to 1450. The physical evidence confirms this. The Minster, one of the largest and most magnificent ecclesiastical buildings in Europe, was completed. Several of the parish churches were rebuilt on a grander scale; guildhalls and fine timber-framed town houses were erected. In spite of sporadic but virulent outbreaks of bubonic plague, which decimated the population, immigration more than made up the numbers. People from country areas in the North of England moved into York looking to enhance their economic prospects in the bustling city and in most cases they probably failed to do so, at least in the first generation. Substantial numbers of Flemish weavers and German merchants also arrived. Many became well-to-do.

York at this time was probably second only to London in wealth and importance. It was a hive of crafts and industries, mostly small-scale by today's standards. Its agricultural hinterland provided it with many of the raw materials for such industries as milling, baking and brewing.

Before Britain had an industrial revolution in the modern sense, the rearing of sheep and the manufacture of woollen cloth was its staple industry. In early times, wool was largely exported to be worked into cloth in the Low Countries. In the fifteenth century, York sensibly started manufacturing cloth itself, and attracted men in the weaving, dyeing, fulling and cutting trades. The resulting cloth earned a good reputation and was exported through Hull to the Baltic and the northern German states in particular. Other industries for which York was noted included bell-founding, stained glass-making and the manufacture of ecclesiastical furniture and fittings. Very fine examples of local painted glass may be found, for example in the churches of All Saints, North Street and St Michael-le-Belfrey, Minster Yard. The port of York was extremely busy during these halcyon days. The city's prosperity is recalled by the surviving medieval guildhalls, such as that of the Merchant Taylors, off Aldwark, which was built about 1400. Further evidence of York's wealth and self-confidence can also still be seen in its surviving bars, or city gates.

York was favoured by a number of monarchs over the centuries – monarchs who, it has to be said, did not usually have a great track record so far as luck or general popularity was concerned. They seem to have cultivated York as a northern bastion of support, a counterbalance to their lack of support elsewhere. Richard II (*r.* 1377–99) often stayed in the city and considered making it his capital. He clearly valued the reception he received and responded by granting the city a number of privileges that rendered it independent of the rest of Yorkshire. From about 1350 York began to stage a saga of religious plays each year, sponsored by the city's various guilds. These plays became well known and even fashionable and drew many visitors. We know that Richard attended and enjoyed them in 1396.

From about the middle of the fifteenth century and for about a hundred years, York went into the economic and social doldrums. Businesses folded, confidence lapsed, little new building took place, people migrated elsewhere, and the population fell. The cloth industry left for the West Riding, where towns such as Leeds and Halifax began to exploit a number of natural advantages for textile production. As ships became bigger, York found

itself disadvantaged as an inland port because many of the newer vessels were larger than their predecessors and proved unable to navigate the Ouse.

Although York found itself embroiled in the so-called Wars of the Roses, this fact seems insufficient explanation for the city's decline because the 'wars' consisted of a drawn-out series of skirmishes involving relatively small numbers of combatants rather than major set-piece battles, and there was a lack of serious disruption to society in Yorkshire or anywhere else. The initial engagement of the war took place close by at Stamford Bridge in 1453 and in 1460 the Duke of York was defeated and killed by the Lancastrians at the Battle of Wakefield. His head, mockingly adorned with a paper crown, was first of all placed on the Ouse Bridge for all to see and later decorated a spike on Micklegate Bar. In 1461, the appalling bloodbath of the Battle of Towton, close to Tadcaster, was decisively won by Edward IV, who promptly entered York and with gory relish substituted a number of Lancastrian heads. Edward was not one to forget grudges and he never forgave the city for its Lancastrian proclivities. It was another matter with his younger brother, Richard, Duke of Gloucester. He took the city and its people to his bosom and they responded positively. As King between 1483 and 1485, he lavished favours on the city and spent considerable time there. When threatened by the invasion of Henry Tudor (the future Henry VII), the city sent a contingent of soldiers to assist him in the inevitable showdown. Unfortunately they arrived at Bosworth too late to affect the outcome. To this day, the people of York will hear no wrong of Richard, the man so demonised by Shakespeare.

Whatever is thought about the seizure of the throne by Henry Tudor, he brought about a long-needed *rapprochement* with Scotland through the marriage of his daughter to the Scottish king, and this helped the North of England to feel more secure and stable. His son, Henry VIII, made himself head of the Church in England and later dissolved the monasteries and sequestered and sold their property. This was a step too far for many traditionalists in the conservative North, and, combined with various economic grievances, led to significant unrest, culminating in the curiously named Pilgrimage of Grace in 1536. York, in the thick of things, was occupied by rebel forces for two months, and the insurgents enjoyed enthusiastic local support. Henry outwitted the leaders by promising various concessions and then, when things had quietened down, extracting a frightful revenge. He had a number of monks hanged and subjected the rebel leader, Robert Aske, to a slow and agonising death – hanged alive, in chains, at Clifford's Tower.

The English Reformation was a body blow to York. Not only was the city traditionalist in its religious sympathies, but the presence of numerous monasteries generated considerable business for the economy. The members of the various monastic orders, the contents of the buildings, and frequently much of the fabric of these institutions disappeared very quickly. Priceless artefacts such as sacred sculptures, vestments and plates were sold off at bargain-basement prices to spivs and speculators. The lead was stripped from roofs. The buildings acted as quarries of high-quality stone, which was reused as masonry. Further depredations took place during the reign of Edward VI (1547–53). This time it was the turn of the parish churches to be systematically stripped of items associated with Catholicism, and the chantry chapels attached to many churches were abolished. The people of York grumbled about these events but had little other option than to accept them and get on with their everyday activities. However, they were hugely enthusiastic about the accession

to the throne of the avowedly Catholic Mary I. Their acclaim was such that she considered moving her court to York to be among those she thought of as her friends.

If any good can be said to have come of these changes so far as the citizens of York were concerned, it is that the Pilgrimage of Grace convinced Henry VIII that a strong, more local administration was needed in the North of England. He established the Council of the North, which eventually occupied the King's Manor, and it did much to placate the feelings of those who believed that the interests of the North were being neglected by government based in London. Additionally, because the council adjudicated in all manner of disputes, there was much work for lawyers and bureaucrats. It was good for York – or at least it was good for them.

Out with the Tudors, in with the Stuarts... and out with the Stuarts

Elizabeth I came to the throne in 1558 when York was slowly climbing out of its moral and economic depression. By the middle of the seventeenth century, York could boast third position behind London and Bristol in terms of size and wealth. Trade was buoyant, new state-of-the-art buildings were going up, and even overseas commerce had revived, aided by the granting in 1581 of a royal charter to the Company of Merchant Adventurers.

The ructions created by the English Reformation had, however, left behind a bitter legacy of religious bigotry and hatred. In 1569/70 a Catholic uprising took place in the North, led by the earls of Westmorland and Northumberland. This occurred around the time that the Pope excommunicated Elizabeth and absolved her subjects from the requirement that they had to obey her. This only intensified anti-Catholic feeling and led to various measures of discrimination, including the persecution of Catholics who did not attend Protestant services. In 1572 Northumberland was captured and publicly executed in the city centre. It was a time of suspicion, fear and mistrust, even among neighbours. There was a general feeling that the Pope wanted to restore the status of the Catholic faith in England so that the country would be as it had been before Henry's actions. It was also believed that the Pope was trying to persuade the hated King of Spain to restore Catholicism by military means. The concept of an international Catholic conspiracy became more plausible when it was revealed that Jesuit priests had secretly infiltrated England to ensure the covert continuance of Catholic ritual and worship and to boost the morale of – and encourage resistance by – the country's Catholic population. It is perhaps hardly surprising that in such a torrid atmosphere, forty-one Catholics were executed at the Knavesmire for their beliefs between 1582 and 1603. Those who took in and hid Catholic priests on the run knew the risks they were taking. One such was Margaret Clitherow, who lived in the Shambles and who was martyred for her troubles in 1586. She was subsequently canonised. Another York native was Guy Fawkes, who was executed in London in 1606 for his part in the infamous Gunpowder Plot. For many Protestants, that plot only confirmed the lengths that international Catholicism was prepared to go to wind back the clock of history.

With the crowns of England and Scotland united in 1603, York became a natural stopping-off point for political functionaries travelling between the capitals of those

countries. It also meant that James I and Charles I dropped by from time to time. In the seventeenth century, York began to evolve yet another role – that of a combined provincial administrative centre for the North of England and a leisure and pleasure resort for those who considered themselves to be the northern social elite. Manufacturing, trade and commerce in York declined at this time as the city increasingly based itself on what we would now call the service or tertiary sector of the economy. The building of many substantial town houses for affluent residents reflected this new development.

The middle decades of the seventeenth century were exceptionally turbulent as King and Parliament battled to defend and develop their respective interests. York was drawn into this turmoil because Charles I made the city his temporary capital for a few months in 1642, after which it served for two years as his northern military base. The citizenry was by no means unanimous in supporting the royal cause. However, a large military presence gave them little option but to go along with it or at least keep quiet. It was also, of course, good for business, at least temporarily. A force of about 30,000 Parliamentarian soldiers surrounded and besieged the city and subjected the walls to a frightful battering, causing considerable damage, especially in the area around Walmgate Bar.

York fell to Parliament in 1644, shortly after the decisive Battle of Marston Moor, and that event marked the end of York's serious involvement in the hostilities. In the decades that followed, neither Royalists nor Parliamentarians were absolutely sure just where the loyalty of the people of York lay; perhaps they themselves were not certain either. They seem to have welcomed the restoration of the monarchy in 1660, but anti-monarchist feeling was sufficiently strong for an extremely unpopular garrison to be kept in the city to browbeat the locals. If Charles II became unpopular, that was nothing in comparison with the loathing extended to James II. The local citizenry applauded his fall from the throne and the accession to the throne of William of Orange, and they put up no resistance when William's forces entered the city in 1688 to arrest the Governor of York and other pro-Stuart factions.

This event marks the end of York's involvement in major political controversy. It also marked the beginning of a period in which, while religious issues did not leave the public agenda, there was generally an improved sense of tolerance; Church of England, Roman Catholic and Nonconformist modes of worship managed to exist alongside each other, albeit somewhat uneasily at times.

Celia Fiennes, that indefatigable traveller and chronicler of the 1680s through to the 1710s, visited York during this time. She was hugely impressed by the Minster, but her overall impression of the city was not particularly favourable. Of York she said:

> It stands high but for one of the Metropolis and the See of the Archbishop it makes but
> a meane appearance, the Streetes are narrow and not of any length, save one which you
> enter of from the bridge, that is over the Ouise [sic] which looks a very fine river when full
> after much raine – it is but low by comparison with some rivers – it bears great Barges,
> it looks muddy; its full of good fish we eate very good Cod fish and Salmon and that at
> a pretty cheape rate tho' we were not in the best inn for the Angel is the best, in Cunny
> [Coney] Streete; the houses are very low and as indifferent as in any Country town, and
> the narrowness of the streets make it appear very mean.

York in Georgian Times

In the eighteenth and early nineteenth centuries, York continued to develop in its role as the social and cultural capital of the North, as a shire town, as the seat of an archdiocese and as a market centre. The city was dominated by the gentry and it boasted many men of literary and artistic achievement. Its earlier trading, commercial and industrial activities were greatly reduced or had gone completely. Many fine houses in York date from this period and they were now being built in brick. Micklegate provides examples. The *York Mercury* was the city's first newspaper, and appeared in 1719. The more successful *York Courant* appeared a few days later. The city gained further social facilities such as the Assembly Rooms, a theatre, and concert rooms. A piped water supply was laid on between 1677 and 1685. The first regular stagecoach services to London ran in 1703. It was a period of stability and quiet growth. York's population grew from about 12,000 in 1750 to 26,000 in 1831. Daniel Defoe, in his *A tour thro' the Whole Island of Great Britain* – undertaken in the 1720s – described York in these approving words: 'There is abundance of good company here, and abundance of good families live here, for the sake of the good company and cheap living: a man converses with all the world here as effectually as at London ...'

Only rarely was this serenity disturbed. The city was put on alert when the vapid coxcomb known as the 'Young Pretender' set out in 1745 to invade England, march on London, and seize the throne. This venture did not attract the support Bonnie Prince Charlie had expected and it proved disastrous, at least for those who had been stupid enough to follow him. They were ruthlessly massacred by the forces of the Duke of Cumberland, although their 'leader' made sure to escape. Twenty-two Jacobite rebels were executed. The heads of two of them were exhibited on Micklegate Bar, the last time this building was used for such a ritual. More peaceful political activity took place some years later, when York was the centre of a vigorous campaign for democratic rights, including particularly an extension of the franchise.

York benefited greatly from improved methods of road-building and maintenance and by the development of turnpikes. A comprehensive system of long- and short-distance stagecoach services developed and what until 1761 had been a journey of four days to London had been reduced on the faster services to 20 hours in 1836. Parts of the Foss were turned into a navigation and improvements were made to the Ouse, resulting in a modest increase in water-borne traffic serving the city. Various small-scale industries developed and two firms that originated as small family confectioners eventually evolved into companies the size of Rowntree's and Terry's. The industrialisation that was such a feature of Leeds and much of the West Riding, however, passed York by. The town did not have the water power and the coal required for large-scale development of the steam-powered factories and mills that were a feature of the Industrial Revolution. That did not prevent the public hanging in 1813 of nineteen men found guilty of machine-breaking in what were known as the Luddite riots.

For all that York did not go down the road of large-scale industrialisation, it developed a tradition of smaller industrial enterprise. A long-established industry in York was bell-founding. While this industry, which had originated in the late sixteenth century, died out in the 1790s, iron-founding came to fill the gap and one company that built up a good

reputation locally was Walker's in Walmgate; examples of its handiwork can still be seen in the York area. Silversmiths and goldsmiths flourished until the nineteenth century, as did clock- and watch-making. The presence of these latter businesses in York is probably a reflection of the city's role as a centre of retailing and socialising for the 'county set' of its hinterland. In its own right it had a sizeable population of affluent middle-class consumers as well. The same factor may explain the presence of cabinet-makers. There were several manufacturers of small and intricate scientific instruments and it is possible that the presence of one or two such craftsmen attracted others in similar or related trades.

York continued to produce and attract many men of eminence for whom elegant town houses were built in Micklegate and Bootham, for example. However, for the first time some of the city's wealthy inhabitants were choosing to move out of town and into the suburbs because areas within the walls, such as the Bedern and Walmgate, were dark, sinister and filthy rookeries. The grand houses in which the rich had formerly lived were often let out as what are now called multi-occupied dwellings; some rapidly became slums.

One feather in York's cap that deservedly helped it to gain international recognition was the opening by Samuel Tuke and other Quakers of The Retreat, where patients suffering from mental health problems were treated in what for the time were radically humane and sympathetic ways. It opened in 1795. Indeed, York had an enviable reputation in things medical because in 1743 the first general hospital in the North was opened as the result of a bequest from Lady Elizabeth Hastings. This hospital was partly built due to a tradition of the city being served by eminent medical men, and it attracted George Stubbs (1724–1806). In 1744 he set himself up as a portrait painter at Leeds, but realising that his knowledge of anatomy was insufficient to do his subjects full justice, he attended large numbers of dissections, which helped him to develop the virtuosity in depicting the human form for which he later became well known.

The monastic tradition was very strong in York before the Reformation. The duty of care for the ill and infirm that was required of monasticism may explain the existence around York in successive centuries of gardens and nurseries where large numbers of medicinal herbs were cultivated. It is perhaps this legacy that explains the very marked local interest in the growing of purely ornamental plants and flowers.

York in Modern Times

York was first connected to the railway in 1839. It was a sufficiently important city in its own right to be connected to the growing railway system at this relatively early date. The arrival of subsequent lines turned York into a major railway junction and led to a modest industrialisation of the city. In Walmgate the iron foundry of John Walker expanded rapidly once the railway was able easily and cheaply to bring in the coal and iron ore he needed. The railways built workshops for carriages and other rolling stock and became a major employer. George Hudson (1800–71), the 'Railway King', was and remains a controversial character, but there is little doubt that it was his machinations that enabled York to develop and prosper as a railway centre. Without his activity, the city might well have stagnated as a relatively provincial backwater like Ripon, which was overtaken by major industrial

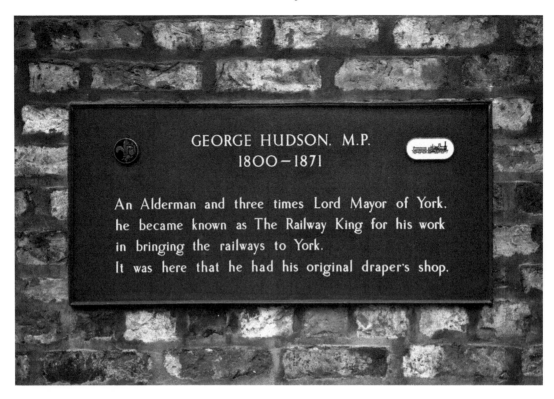

GEORGE HUDSON. M.P.
1800 – 1871

An Alderman and three times Lord Mayor of York.
he became known as The Railway King for his work
in bringing the railways to York.
It was here that he had his original draper's shop.

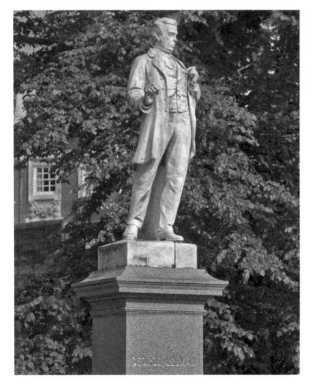

Above: A plaque in College Street contributes to the resucsitation of the Railway King's reputation.

Left: The statue of George Leeman, Station Road.

cities of the North such as Leeds, Bradford, Hull and Newcastle. Hudson was a Tory and for years was engaged in a merciless and venomous battle of words and wits with the city's leading Liberal councillor, George Leeman.

The city is probably not thought of as a railway town in the same way as Crewe, Doncaster, Derby or Swindon, for example, but railways have had an incalculable effect on its modern history. It possesses one of the finest railway stations in Britain, but there is much else – statues, the war memorial, housing, pubs, chapels and churches, for example – whose existence can be traced back to the major presence of the railways. Railwaymen have played a major role in local government, several having served as Lord Mayor.

The railways had an enormous impact on many aspects of life in York. The coming of the railway ended passenger sailings on the Ouse and reduced (but did not immediately destroy) the carrying of commercial traffic on the river as well. The railways stimulated three economic activities that became characteristic of York: the cattle market, flour-milling, and the manufacture of confectionery. York had long been a centre for trading livestock, but from 1826 to 1971, a busy and prosperous market was in existence close to the south-east corner of the city walls and as soon as the railway arrived, the market benefited from its presence. From 1971 the market was relocated to the periphery of York, where it could more easily be served by road transport. There were extensive flour mills in the Foss Islands area and these were served by rail.

Perhaps the industry most associated with York in the public mind is the manufacture of confectionery. The main firms concerned were Rowntree's and Terry's. After using several premises around central York, Rowntree's based its production at a site on the north-eastern edge of the city, utilising extensive railway sidings built for the now-closed line to Pocklington and Hull. In the 1950s, Rowntree's employed something like 13,000 workers and much of its production left the factory by rail. In 1926 a sugar beet factory was opened near Poppleton, just north of York. It was designed to be rail-served and during the sugar beet season or 'campaign' as it was called, vast quantities of that raw material would arrive in trainloads, as would the coal and lime required for it to be processed. Less known was the North Eastern Railway's laundry at Foss Islands. This handled the linen from the company's many hotels and refreshment rooms. In 1929–30, when it was owned by the LNER, it handled 4 million items.

York's record in matters of public health, despite improvements in local government in the nineteenth century, remained a poor one. Diseases like cholera, transmitted by infected water, made lethal visitations, as did typhus. The city within the walls became grossly overcrowded – many poor Irish arrived to escape the miseries of the 1840s back at home – and there was very little slum clearance. The Bishophill, Hungate and Walmgate districts were notoriously overcrowded. All this meant that whereas interventionist public health measures were being inaugurated elsewhere and death rates were falling, in York they continued to rise.

The social and economic problems prevalent in late-nineteenth-century York were highlighted by local Quaker businessman and philanthropist B. S. Rowntree (1871–1954). In 1899 he carried out a detailed investigation into the lives, incomes, expenses and outgoings of every working-class family in York with at least one wage-earner. His methods were rigorous and his conclusion was that over 43 per cent of working people

Terry's disused factory, from Campelshon Road.

in York and 27 per cent of the total population was living in poverty. They were trapped in a virtually inescapable circle of deprivation and despair – what would now be called 'social exclusion'. Rowntree's findings were a searing indictment of the economic and social policies of nineteenth-century Britain and raised the question of how it was that this could happen in what was still the richest and most powerful country in the world. When his investigation was published in 1901 as *Poverty: A Study of Town Life*, it was a bestseller and went on to have a considerable influence on the formulation of social policy. Partly under the influence of this report, Rowntree's father Joseph (1836–1925) developed New Earswick, a garden suburb, in order to provide salubrious housing and surroundings for working-class people.

For much of the twentieth century, employment in the confectionery industry at Rowntree's and Terry's grew while railway employment slowly contracted. The space covered by the city and its suburbs increased rapidly as the central areas lost their population – but this, of course, is a process common to most British urban settlements. Perhaps surprisingly, given its strategic importance as a railway centre, York got off lightly from aerial bombing in the Second World War. The worst destruction was that caused by the Baedeker Raid of 29 April 1942, which missed the Minster but caused severe damage at the railway station. Although thankfully less than a hundred lives were lost in air-raids on York, large numbers of buildings were damaged or destroyed, including the church of St Martin le Grand and the Guildhall. Since then much more serious damage to the historical infrastructure has been done by vandals in the form of insensitive town planners and aesthetically illiterate architects pandering to the private motorist and the

needs of the motor vehicle. Despite all their efforts, which reached a peak in the 1960s and early 1970s, York collectively remains a very special urban architectural experience, and various dedicated conservationists, archaeologists and others must take great credit for this. A huge fillip to the city has been the establishment of the University of York. This put the city right back on the map of educational eminence, of which there is a long tradition. It has contributed greatly to the cultural life of the city, and it also contains some striking twentieth-century architecture. York heaves with tourists for much of the year, so much so that there is almost pedestrian gridlock in the most visited parts of the city – studiously avoided whenever possible by local people going about their business.

There are pockets of deprivation and despair in York and it cannot entirely escape the crime, the ennui and the sense of purposelessness that are a feature of sections of modern British society. For all that, it is a marvellous place and does well in its task of managing the difficult combination of being a modern, dynamic, small-to-medium working city with the responsibility of stewardship for its extraordinarily rich historical heritage. The authors hope that their love and enthusiasm for York comes across in what they write and illustrate.

What follows in the main body of the book is an alphabetical tour of items of interest, oddities, curiosities and eccentricities that can be seen while walking the streets particularly, but not exclusively, in central York – meaning that part of the city within the walls. The emphasis is on 'the street', so we only rarely venture indoors, although we are only too aware that a cornucopia of interest is also to be found inside the buildings of York. Clearly the possibility of viewing such items would often be complicated by issues of access. Where we have occasionally ventured inside, it is to places that are open to the public during reasonable hours. Inevitably we have had to make choices as to what to include and we do not pretend to be comprehensive. We have, for example, not gone inside the Minster. All sorts of guides, both living ones and those who have survived in their writings, can describe the interior of that building far better than we could. Our intention is hopefully to add to the interest the visitor or the local person derives from walking the streets of the city, wanting to know more about what he or she is seeing and about the history of the place. No prior knowledge is assumed and we have deliberately kept away from including much architectural detail. York has played a major role in the history of the English nation and one concept underpinning our approach is the sense both of continuous change but also of continuity. In playing out its historical role, it has reflected much of what has happened to England over time as well as making its own unique contribution and response to those events.

We feel that no matter how well we know York, we could forever go on finding new curiosities and more information. We are only too aware that we are attracted to the odd, curious and eccentric, and we can only hope that the book gives readers as much pleasure as researching, walking, looking, noting and photographing gave to us.

York – From A to Z

A

The Ackhorne
We like pubs with unique names. This old building was first used as a pub in the 1780s when it was the Ackhorne, but it was familiar to one of the authors for thirty years when it had the modernised spelling 'Acorn'. It makes a handy watering hole before or after a train journey. About twenty years ago it reverted to Ackhorne. The name Acorn was rare enough, but no other pub in the UK sports the Ackhorne name. It is located in the narrow St Martin's Lane off Micklegate, in close proximity to the church of St Martin-cum-Gregory, and can be described as a pub with traditional values.

All Saints, North Street
There is Roman masonry visible on the outside of this church, but our greatest interest is in the interior of the building. There is a marvellous collection of medieval painted glass, second only to that in the Minster. One oddity is a figure in a fourteenth-century window who is shown wearing a pair of glasses. For fans of the green man or foliate head, bosses bearing this motif can be found in the nave and aisles. The tall spire of All Saints acts as a visual focus in this part of the city. These early-fifteenth-century houses stand close by (see overleaf).

All Saints, Pavement
One of the best-known of York's ancient parish churches, All Saints stands at the junction of Coppergate and Pavement in one of the busiest parts of the city centre. It is difficult to miss because it gets in the way of the flow of happy shoppers, some of whom probably resent its presence as they prowl the city, gorging themselves on the delights of consumerism. 'Coppergate' is probably a derivation of 'street of the coopers'. 'Pavement' got its name because it was an early example of a paved street. Public proclamations were often made on Pavement and executions were also carried out there. Victims included the Earl of Northumberland. He was executed in 1572 for his part in leading a serious Catholic uprising in the northern counties and his head went on to decorate a spike on Micklegate.

The best-known feature of All Saints is unquestionably its unusual octagonal openwork or lantern tower. A lamp was formerly lit in this tower, supposedly to assist benighted

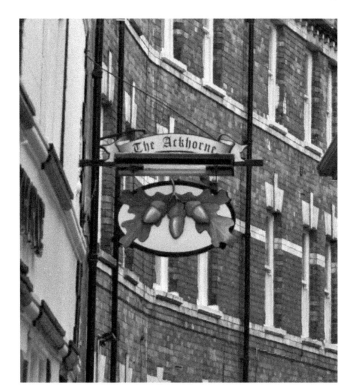

Right: The Ackhorne pub, tucked away off Micklegate.

Below: A timber-framed and timber-jettied building in All Saints' Lane.

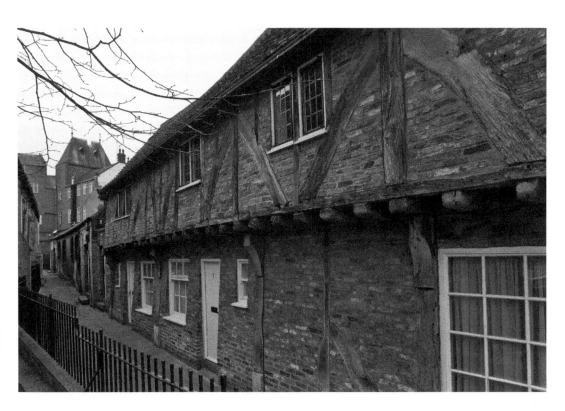

The tower of All Saints, Pavement.

travellers making for the city through the Forest of Galtres. This was a huge area of woodland north of the city and almost reaching to its walls. If this story is true, it would surely have made more sense to place the beacon somewhere higher. How about the Minster? However, a light still shines in the hours of darkness and acts as a memorial to the local people who perished in active service in the two world wars.

A knocker on the north door can be seen and it shows a sinner being consumed by a lion, although it is not immediately evident that it is a lion. This is thought to be a 'sanctuary knocker'. The right of sanctuary seems to modern eyes to be one of the more curious medieval ecclesiastical practices. Monasteries and a number of major churches possessed this privilege. It allowed a fugitive from justice to escape from his pursuers by seeking the protection of the Church. In some places entry to the church itself was required; in others it was enough to enter the precincts or, more commonly, to seize the ring-shaped knocker on the main door. The fugitive had to confess his offence – only two were *ultra vires* as far as the Church was concerned: treason and sacrilege. Sanctuary involved the criminal forfeiting all his property. He was allowed to stay on the premises for up to forty days, after which, dressed distinctively and usually holding a cross, he had to make his way as fast as possible to the nearest seaport and ship across to the Continent, where he had to remain in exile for the rest of his life. No one, not even the King, was allowed, on pain of excommunication, to interfere with the fugitive either when he was on the church premises or as he made his way out of the country. This anomalous practice was abolished in the reign of James I (1603–25).

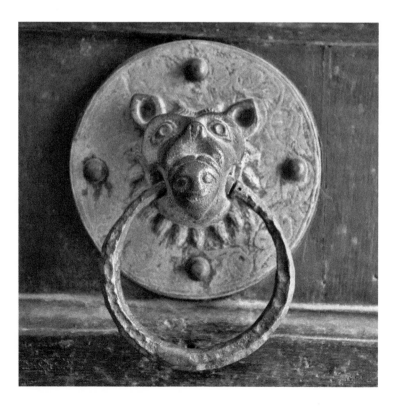

The sanctuary knocker, All Saints, Pavement.

Anglian Tower
This small stone tower, the existence of which had been forgotten until it was literally unearthed in 1839, is probably Roman. It stands close to the Multangular Tower, and access is via the Museum Gardens. It was restored about forty years ago.

Art Gallery
York's main municipal art gallery is in Exhibition Square. Opened in 1879 for the Yorkshire Fine Art and Industrial Exhibition, the gallery and much of its contents were bought by the city in 1892. This is a gallery of major national importance. It contains many fine works, including Italian panel paintings of the fourteenth and fifteenth centuries, Flemish and Dutch items of the seventeenth century, and fine nineteenth-century French works. There are numerous British items and many paintings by Yorkshire artists and of places in Yorkshire. On display are several paintings by locally born artist William Etty (1787–1849).

Assembly Rooms
Completed in 1735, the Assembly Rooms in Blake Street provided York with a suitable location for the balls, concerts and other social events required by the fashionable social set of the city and surrounding country. They were designed by Lord Burlington, who was very much a self-taught architect; he produced a building displaying many of the motifs of the Palladian style.

B

Baile Hill
Off Cromwell Road, this is the lesser-known of the two castles built by order of William I in 1068/9. It was possibly built on earlier fortified earthworks and was a typical motte-and-bailey castle. These were extensively used by the Normans while they were imposing their rule on the unwilling natives of England. Castles of this type usually consisted of a steep-sided high mound or motte of earth, rock and possibly turf, with a stout wooden stockade on the top, often containing a watchtower. A steep wooden staircase provided access to the top of the motte. At the bottom of the motte there was an enclosure, or bailey, where livestock and stores could be kept. The motte itself, and sometimes the whole site, would be surrounded by a moat or a defensive ditch. These castles were designed as bases for cavalry, so that the Norman invaders could range the surrounding countryside, suppressing opposition. They were intended to be cheap, quick and easy to construct. To emphasise their superiority, the Normans often press-ganged native men into acting as labourers – a ritual humiliation of the conquered. These castles were built in huge numbers in the late eleventh century, but York is unusual in being the only town in Britain, apart from London, where there were two. The other, of course, is the better-known Clifford's Tower. Baile Hill was not used as a castle for long, although it saw military service in the Civil War as a gun emplacement.

Baile Hill from the city walls.

Barker Tower
This is a medieval building very close to Lendal Bridge (built 1861–63) and it was once part of the defensive walls of the city. Its name is derived from the York leather industry – a 'barker' prepared animal hides for processing. Close by, on the other side of the river, the derivation of the names of the streets Tanner's Moat and Tanner Row is self-explanatory. This tower is alternatively known as North Street Postern.

Bettys Tea Rooms
Bettys (there is no apostrophe) is one of North Yorkshire's most cherished institutions. The first of its tea rooms was opened in Harrogate in 1919 by Frederick Belmont, a Swiss confectioner, in what had been a very scruffy furniture store. In May 1936, Belmont and his English wife travelled on the opulent Cunard liner *Queen Mary* on her maiden voyage, and were enormously impressed by its furnishings, decor and general ambience. Belmont had a building in St Helen's Square refurbished in a way that could only be described as 'luxurious'. It opened on 1 June 1937. Bettys now has six outlets, including two in York – this is the better-known. These tea rooms are unashamedly traditional (another way of

saying that they are expensive), but the ambience, presentation, quality and service are so good that they remain exceptionally popular. The company has always resisted expanding beyond Yorkshire on the basis that not only is small beautiful, but small also makes quality assurance easier to maintain.

'Mouth-watering' is a typical piece of modern advertising hyperbole; it has even been applied to those pieces of gristly cooked chicken with a nauseous coating of dubious provenance that claim origins in America's Deep South. The adjective, however, can justifiably be applied to the choice cakes and other sweet creations that sit seductively in the window of Bettys. Who could not be seduced by a Fat Rascal?

Bile Beans

The authors have scoured streets up and down Britain looking for 'ghost advertisements', but that on the end of a building in Lord Mayor's Walk has to be one of their favourites. It has the immortal words, 'Nightly BILE BEANS keep you HEALTHY, BRIGHT-EYED & SLIM'. Apart from the fact that it might be difficult to substantiate this bold claim, the whole statement is a polite euphemism, because the function of Bile Beans was to act as a laxative. A bolder advert in a magazine of 1955 is a bit nearer the knuckle. This shows a woman whose face is suffused with misery. It is hardly surprising, because this is the 'before' part of the advert – in other words she is yet to have the good fortune to stumble across Bile Beans. The 'after' shot shows her positively radiating both good health and bonhomie after having savoured to the full the purgative effect of Bile Beans. Her beaming face is accompanied by the slogan, 'Ordinary laxatives couldn't free her from sluggishness and undigested fats – she is a new woman since taking BILE BEANS LAXATIVE PLUS.'

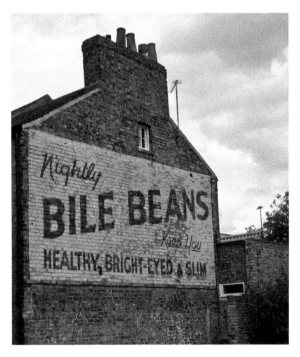

Bile Beans, Lord Mayor's Walk.

Bile Beans were an extremely popular proprietary product invented in Australia in 1899. They were usually advertised as being beneficial for 'inner health'. They disappeared from the shelves in the 1980s.

First appearing in the 1890s, becoming particularly popular in the 1920s and 1930s, and going out of fashion after the Second World War, these advertisements were hand-painted on brick buildings, particularly on gable ends. Weathering, demolition, rebuilding and so on have taken their toll and these advertisements are a disappearing breed, although, as might be expected in a country like the UK, which thankfully still manages to produce genuine eccentrics, they have their devotees.

Another, more faded, ghost advert (*q.v.*) can be seen on a gable end on the right-hand side of Heslington Road if you are travelling towards the university. The company being touted is John Smith's Brewery of Tadcaster. Its trademark magnet can just be discerned. In Merchantgate, between Piccadilly and Walmgate, there are two very clear adverts for a former hardware company.

Stubbs Ironmonger's wall advert, as seen from Piccadilly.

Bitchdaughter Tower

This small tower on the walls near Baile Hill was plundered for stone in 1451 and 1566 when repairs were being made to Ouse Bridge. However, it must have been rebuilt, because in the 1640s it became a gun platform. The authors regret that they do not know the origin of the name, but they are open to suggestions.

Black Bess

A good example of an urban myth is that which says that Dick Turpin made a heroic ride from London to York to establish an alibi for a serious alleged offence, probably committed somewhere around London. He reasoned that if he could be recognised in York quickly enough after the incident, it would prove that he could not possibly have been anywhere near the location at which the crime was committed. So he charged pell-mell up the Great North Road on the back of his faithful and redoubtable 'Black Bess', both horse and rider displaying a quite extraordinary stamina and endurance. They were on time and in sight of the Minster when Black Bess suddenly pulled up. She could go no further. Turpin dismounted to give her some kind words of comfort but then, like a mighty oak under the axe, his brave horse first tottered and then toppled to the ground. She gave Turpin one last, perhaps rather reproachful, glance before her eyes misted over and she expired. Although this was extremely tear-jerking, even melodramatic, Turpin rather callously left the horse where she lay. He hurried on into York to deliberately accost and speak to a number of prominent citizens, whom he hoped would later be able to bear witness that they had indeed spoken with him at a time that proved that he could not possibly have been in Surrey committing a crime so soon before.

A good story, but one invented or enormously embellished by the writer Harrison Ainsworth in his novel *Rookwood*, which was published in 1834. As if this melodrama were not enough, it has been seriously alleged that Black Bess gave up the ghost on Fulford Road. A tree close to the present police station is said to mark the spot where the faithful and heroic creature finally keeled over. There is a possibility that a highwayman did indeed make an epic dash from London to York to establish an alibi. He was 'Swift Nicks' Nevison in the seventeenth century and he was something of a celebrity as far as highway robbery was concerned. Another who may have made the ride out of which Ainsworth concocted his stirring tale was the lesser-known gentleman of the road 'Harrison'.

We can forget Turpin and the noble Black Bess. No one horse could have covered the distance in such a short time. However, Harrison Ainsworth is not the kind of writer to allow the impossible to get in the way of spinning a yarn. In *Rookwood*, the horse is rubbed down with a mixture of water and brandy to keep her fresh and the bit of her bridle is rubbed with raw beefsteak.

The novel is written in a style that is now virtually unreadable. For all that, it is remarkable that in Black Bess, Ainsworth produced what is unquestionably one of the best-known animals in English literature. He is also largely responsible for the popular perception of the highwayman as a dashing, courteous and handsome 'gentleman of the road'. Turpin and most of his kind were none of these things. They were ruthless, savage and brutal. They needed to be. The penalty for being found guilty of highway robbery was death (see page 54). Violence or the threat of it was their stock-in-trade.

Black Horse Passage

York has a large number of what are known locally as 'snickelways'. These are alleys, mostly in the ancient parts of the city, that are too narrow to allow the passage of vehicular traffic. In other towns they might be known as 'ginnels', 'jitties', 'jiggers' or any number of other names. This particular one is off Stonebow and leads towards Hungate. It is somewhat ironic that one side of the alley contains the wall of a former Carmelite priory, because those seeking the pleasures of the flesh used to make their furtive way along this particular passage, intent on enjoying the robust delights offered by the many brothels of the Hungate quarter.

Black Swan, Peasholme Green

Some distance from the major tourist routes, the Black Swan is a very fine hostelry for those discerning drinkers who like a sense of history and traditional values. This building originated as a town house in the late seventeenth century and for many decades it was occupied by the influential Bowes family. In this book we deal largely with what can be seen while walking the streets, and in the case of this pub a very handsome half-timbered frontage attracts the eye. Until about thirty years ago, the timbering was hidden behind a layer of plaster. It would be churlish, however, not to mention that inside the pub is a very fine staircase and lots of open beams and wood panelling, as well as good beer. Once installed inside this pub, the authors have found it difficult to leave.

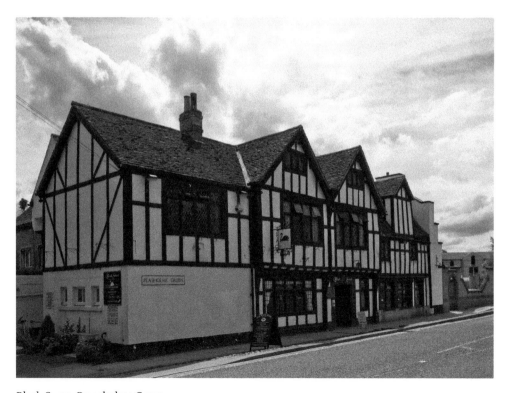

Black Swan, Peasholme Green.

Blue Bell, Fossgate

This volume does not pretend to offer a guided tour of York's pubs. The city is lucky enough to retain many pubs of the sort that are appreciated by people who don't want vast television screens, the sexes eyeing each other up as if at a cattle market, and decibel levels so loud that spoken conversation is impossible and premature deafness inevitable. With the trend being towards the opening of vast hangar-like drink and food emporia masquerading as pubs and often located in redundant banks or shops in town and city centres, this pub makes a refreshing change. It could hardly be smaller, consisting of two tiny well-used and well-appreciated rooms of an unashamedly old-fashioned kind. As a community pub of the sort that can be used by all ages and all classes, the Blue Bell should be praised. It does it so well that the authors thought it would be ungrateful to omit the Blue Bell from this book on oddities and curiosities of York. They visited the Blue Bell to express their gratitude in the only practical manner they thought appropriate. From the street, this pub has a rather fine sign and an old tiled façade of the sort that has become increasingly rare.

Blue Bridge

This footbridge crosses the confluence of the Foss and the Ouse at the bottom of Blue Bridge Lane, close to the city centre. It derives its name from the first bridge that was erected here, a timber bridge painted a trademark blue. It was built in the 1730s in conjunction with

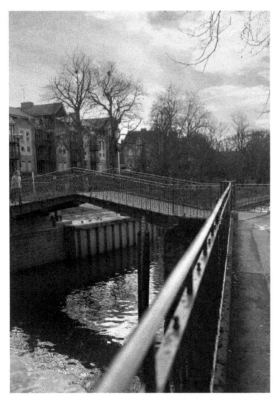

Blue Bridge, looking south-east.

New Walk, which was designed to provide a tree-lined riverside promenade to match Lord Mayor's Walk on the other side of the city. The present bridge dates from 1929/30. A piece of wall in Blue Bridge Lane is the only visible remnant of St Andrew's Priory, a house of the Gilbertine order that was founded in 1202 and dissolved in 1538.

Bootham Bar

This bar marks the site of the main gateway to the north-west of the Roman fortress of Eboracum. It contains fabric dating from Norman times and the nineteenth century. A number of statues can be seen on top of the bar; these were placed there in 1894 to replace earlier carved figures that had been severely eroded by the weather. The remains of a portcullis can be seen. The bar was the scene of shots fired in anger on a number of occasions and the severed head of Thomas Mowbray adorned it in 1405. Further heads – of those who disagreed with the restoration of Charles II to the throne – looked dolefully down from the bar in 1663. Back in the nineteenth century, many of the city's burghers wanted to get rid of the bar, which they regarded as nothing more than a piece of medieval clutter, but fortunately wiser counsels prevailed. The bar has had considerable restorative work done on it to ensure its structural safety and continued existence.

Bronze Commemorative Plaques

York is living history. It has seen just about everything. Wars, floods, fires, riots, pestilence, premature death, heinous criminal acts, acts of monumental stupidity, heroic examples of triumph over adversity, revelations of selfless human goodness and mass celebrations of joy – all these events and processes are part of the complex warp and weft that is the history of the city. York has a priceless accumulation of buildings of historical and architectural interest, but it would not be unfair to say that, generally, people are more interested in people – in the human dimension and the human stories behind the evidence of the past.

Commemorative plaques are pointers to the past. They provide concise historical information that readers can ponder on and, if they choose, go away and find out more about. As would be expected in a city with such a sense of its history, York is well supplied with plaques. There are over 150 commemorative plaques in York and a large number of them were erected by the York Civic Trust. These can be identified by the trust's motif, half of a fleur-de-lis, recognisable as such, and half of a lion's head wearing a crown, which is rather less so. Other plaques have been put up by private individuals, associations or companies.

Burton Stone

On the north side of Bootham, at its junction with Burton Stone Lane, stands the eponymous Burton Stone. No one quite seems to know its significance. It has three carved holes. It has been located in this neighbourhood or close to it since mention was made in the sixteenth century of the stone being a mustering point for soldiers who then went off to fight the Scots. It is difficult to see why they should choose this place in preference to any other local landmark. Some believe it was a boundary stone marking the outer end of the Lord Mayor's jurisdiction. A less prosaic explanation is that the object is a plague stone. Such stones contained holes filled up with vinegar, into which coins were dropped. Those

communities, affected by bubonic plague, were in effect quarantined, but could buy food and other supplies with coins. It was believed that by dropping the coins with which they paid for these items into the vinegar, they would prevent the contagion from spreading to those who brought them their supplies. At that time there was, of course, no germ theory of disease, but it was believed that vinegar somehow prevented the transmission of the dreaded plague. We should never underestimate our ancestors.

C

Castle Museum

Most of York's ancient castle has disappeared, but part of the site is occupied by more modern buildings constituting three sides of a quadrangle. The building on the south-west side houses the Crown Court, while the other two wings contain the Castle Museum, part of which was formerly the debtors' prison (*q.v.*). One part was given over to male prisoners, the other to females. It was opened in the first decade of the eighteenth century. Apart from the spectacular Clifford's Tower, York Castle must be something of a disappointment to children imagining impressive battlements, moats and drawbridges in a place with such a historic feel as York. Such feelings are quickly assuaged, however, upon entering the Castle Museum. This opened in 1938 and even the most fractious infant should find something to grab its attention, not least in what is perhaps its best-known feature. This is 'Kirkgate', a meticulously reconstructed Victorian shopping street in a northern town. The Castle Museum fully deserves its position as one of the UK's most-visited museums.

Cemetery

York Cemetery is in the Fulford district. It was opened in 1837 on what would now be called a greenfield site. It was desperately needed because the existing burial grounds were almost literally overflowing. Approached through fine cast-iron gates made by the local foundry of John Walker and past an engaging little gatehouse, the cemetery has as its centrepiece a chapel in a Greek Revival style with Ionic columns. Headstones and monuments record the city's supposedly great and good and a good many others who went around their daily business less ostentatiously – and were probably no whit less good. Doubtless some out-and-out rogues are also interred within the cemetery's precincts. Who knows, some of them may even have been local councillors. For many years, this cemetery declined and became vandalised and semi-derelict, but fortunately money was raised by the York Cemetery Trust and it underwent a much-needed renovation in 1988.

Incidentally, the foundry of John Walker made the splendid gates of the British Museum a few years later.

Central Methodist Chapel

Otherwise known as the 'Centenary Chapel' this imposing building stands in Colliergate close to where it meets Pavement. The Methodists originated in the eighteenth century as a protest against, and later a breakaway from, the Church of England, which they believed had been corrupted by worldliness and a lack of spiritual zeal.

A view across York Cemetery.

This building was erected in 1839/40 and was designed on a grandiose scale, perhaps rather grander than John Wesley, the founder of Methodism, had had in mind when he was developing his critique of Anglicanism and framing an alternative style of devotion. It could pass for a town hall.

Cholera Burial Ground

In Station Road stand a few headstones, reminders that the cholera burial ground was located here before the railway station was built. York suffered a severe outbreak of cholera in 1832 and this site was commandeered as an emergency extra burial site, largely away from areas of housing. The number of headstones is no indication of the number of interments at this spot. It is likely that many of the headstones have disappeared and pauper burials would have been in unmarked graves. The authorities usually required burials to take place immediately after death. This particularly offended working-class sensibilities, because giving the deceased a good celebratory send-off was regarded as a very important part of their culture – a mark of respect to the deceased as well as a social bonding process for those left behind.

It did not help that in the nineteenth century opium and laudanum were freely prescribed for sufferers from cholera. These could produce states of coma virtually indistinguishable from death, thereby arousing one of mankind's most primeval fears, that of premature burial. To add insult to injury, post-mortem muscular spasms were common and these mimicked life even in those who without question had died of cholera. What a source of potentially tragic confusion.

The cholera burial ground, Station Road.

Cholera is a highly infectious and acute intestinal disease caused by the bacterium *Vibrio cholerae*, which is ingested in polluted water. The most prominent symptoms of cholera are uncontrollable diarrhoea – leading to great fluid loss and dehydration – agonising muscle cramps, circulatory collapse, and, for some of those afflicted, death. A sufferer described the pain as like the sensation of having 'a sword put in on one side of the waist, just above the hip bone, and drawn through, handle and all'. The first known outbreak in Britain was at Sunderland on Christmas Day 1831 and the disease spread with terrifying speed, a total of 32,000 people dying across the United Kingdom in that epidemic alone.

City Walls
The walls stretch for nearly 3 miles. They constitute the longest system of urban defences in Britain and are also the best preserved. A few short stretches have disappeared and the city can be considered lucky to have the walls at all, given that men of influence in York seriously wanted to dismantle them at the end of the eighteenth century. This aroused a storm of controversy and led to Parliament passing an act specifically stating that the city walls were inviolate. Over the subsequent years they have undergone minor curtailments, especially at the bars or main gates. They all had barbicans, clever devices whereby any attacking force was channelled between high walls in a space extending from the outer to the inner gates – in the limited space the defenders could pepper the attacking soldiers with missiles. These barbicans were seen as obstructions to the flow of traffic and only

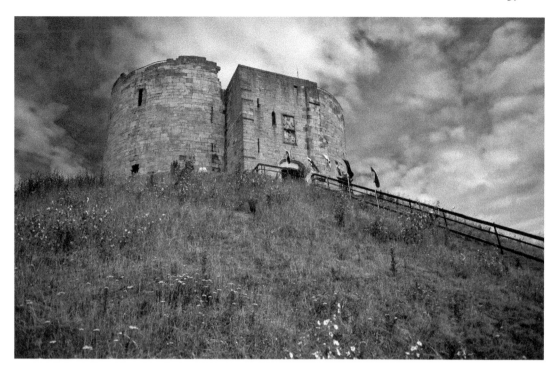

Clifford's Tower.

the one on Walmgate survives. The walls are almost entirely constructed of an attractive magnesian limestone quarried around Tadcaster, not far away.

A promenade along the walls provides fascinating panoramas of the city, which are greatly appreciated by visitors.

Clifford's Tower

Many visitors to York make a beeline for Clifford's Tower. The steep sides attract those who want to dash up them to show off and others equally keen to roll down, in spite of such practices being banned. For those prepared to stagger up the fifty-five steps, a fine view over the city is afforded from the top of the walls.

The mound is a very fine example of a motte (see page 26) and was one of two that guarded the confluence of the Foss and Ouse rivers. It has enjoyed a much longer life than its nearby companion. At first this motte was surmounted by a timber building. The masonry tower to be seen today was erected between 1250 and 1275. It would have dominated a landscape that was far wetter than today's (even when the rivers are high). The courses of the rivers were much less defined, their margins were extremely marshy, and the Foss had been dammed to create a large lake known as the King's Pool (or the King's Fishpool), which, while providing fish for culinary purposes, also acted a defensive moat. It is likely that the mound on which Clifford's Tower stands was also surrounded by a water-filled moat fed from the pool or one or other of the rivers. By the time the masonry version of Clifford's Tower was completed, it had become part of a large and complex

castle only the faintest traces of which survive. The name 'Clifford's Tower' seems only to have been adopted around 1596. In terms of military architecture, the tower is unusual for its clover-leaf design.

Coffee Yard

This is one of York's innumerable snickelways, in this case providing a link from Stonegate to Grape Lane. The snickelways are fascinating and few are more so than Coffee Yard. It is long and parts of it are low and narrow; it contains a dog-leg and traverses an area that was previously run-down but has undergone considerable renovation. It passes Barley Hall, which has been restored to provide a sense of how town life was in York in the fifteenth century. The name 'Coffee Yard' is comparatively recent and recalls the fact that York's earliest coffee house was here in what was previously called 'Langton Lane'. It is likely that the first coffee house in Britain was opened in the City of London in 1652. These establishments were essentially urban phenomena and they spread from London first of all to Oxford, Cambridge, Edinburgh, Glasgow and Dublin. York's pioneering coffee house was probably in business by 1669. Coffee houses had an important influence on British history, because their golden age in the eighteenth century coincided with an explosion of scientific enquiry and the development of learning. Coffee houses came to be frequented by the cognoscenti of the arts and sciences. The one in York would have attracted the city's 'movers and shakers' – leading members of the business community, professional men, artists, writers, intellectuals and pseudo-intellectuals – who could show off their knowledge or engage in debates with the stimulus of coffee but without the belligerence and incoherence that often followed the consumption of alcohol.

Coney Street

The derivation of the curious name of this bustling city centre shopping street has nothing to do with rabbits – 'coney' being an alternative word for rabbit and a word that appears to be slipping out of use. It probably means something like 'King's Street', and refers to an erstwhile Viking king.

D

Davy Tower

A medieval stone tower stands at the junction of Tower Place and South Esplanade. The eponymous 'Davy' occupied the tower at some point during the medieval period. At one time a strong chain across the river was used to prevent enemy shipping entering the port area of York. On the south bank it was attached to the now long-vanished Hyngbrig Tower. The chain went out of use from 1553. It is thought that the Davy Tower once contained a brothel catering for the requirements of lusty sailors employed on ships on the Ouse. This tower probably does not benefit from having had a brick summer house placed on top of it around 1750.

Dean's Park

This small park is located just north of the Minster on the site of part of York's Roman legionary fort. Later the Archbishop's Palace was on the same site. Of this building only a

chapel (currently the Minster Library) and a row of arches (which have been adapted for use as a war memorial) survive.

Debtors' Prison

This building, erected between 1701 and 1705, is made largely of stone taken from the ruins of York's medieval castle. It is a quite imposing, even monumental, U-shaped Baroque structure sporting a rather incongruously undersized bell turret. The prison is altered internally and now houses part of the highly rated Castle Museum.

As its name suggests, it housed debtors. The idea of incarcerating debtors in prison seems a curious one by today's standards. The practice was inaugurated in 1350 by Edward III and was meant to deter people from getting into debt, to punish them for their fecklessness, and to ensure that the debts were repaid. Debtors were usually allowed daily release to obtain employment and earn money to discharge the debt, but this of course could take a very long time if the debt was a large one. The idea was that friends and relatives of the debtor would take pity on him or would be so shamed by his imprisonment for debt that they would get together to find the necessary money to obtain his release. In theory, the creditors would therefore get what they were entitled to. In reality it did not always work like this and some debtors stayed in prison for decades and what they owed was never paid off. Some cynical and inveterate over-spenders were only too happy to be placed in prison because they were then protected from the actions of further creditors seeking the restitution of what they were owed. Some debtors lived in style, apparently with plenty of money to spend on the good things of life. Money could buy them whatever they wanted. They might live, wine and dine of the very best, accompanied by their families. The well-to-do debtor could therefore exploit this anomalous system – an option not available to the indigent or friendless. Some prisoners trying to do the right thing by their families and heirs chose to reside permanently in gaol in the knowledge that their debts would be cancelled at their death.

Imprisonment for debtors was abolished in 1869, to the relief of some and the deeply felt chagrin of others.

Dorothy Wilson's Hospital or Almshouses

Near the bridge over the River Foss in Fossgate stands this quaint and old-fashioned-looking building, which was built in 1812 'for the maintenance of ten poor Women' – preferably superannuated domestic servants – and also for 'the Instruction of English, Reading, Writing of 20 poor Boys for ever'. This brief statement is a mute witness to changes in the use of English and in social and cultural values. Unfortunately the conditions that breed poverty and illiteracy have not been eradicated in the twenty-first century.

Drinking Fountain

Perhaps strangely, York only possesses one drinking fountain. It stands close to the entrance to the Museum Gardens in Museum Street and was brought into use in 1880.

The nineteenth century was the age of the drinking fountain. For at least half that century, water was frequently polluted and could cause health problems for those who drank it without boiling it first. People were right to be wary of water. In 1859 the Metropolitan Drinking Fountain & Cattle Trough Association inaugurated its first public drinking fountain, guaranteeing that the

water had been filtered and purified. Soon the erection of drinking fountains in public places became fashionable in towns and cities throughout the country, many being inaugurated under the auspices of the MDF&CTA. This body had close links with the temperance movement; one motive for bringing drinking fountains into use was to try to lure the working man away from the 'demon drink' by the provision of free, cold, refreshing, pure water. For this reason some fountains were strategically sited close to pubs. Others were placed in churchyards, with the intention of showing how the Church supported the welfare of ordinary people.

This sponsor of hundreds of Victorian (and later) troughs still exists, now known as the Drinking Fountain Association. It still erects new fountains and restores old ones, and is enjoying something of a renaissance because drinking fountains have made a minor comeback in recent years.

Drinking Troughs of York

In the nineteenth and for the early part of the twentieth century, the horse was the prime mover in the streets and roads of Britain. Those who used horses as a mode of transport for commercial purposes frequently had a very unsentimental attitude towards the creatures they used and would work them until they were literally 'knackered'. It is hardly surprising that the RSPCA and other animal lovers tried to counter what they saw as cruelty by providing places where working horses and the cattle that were frequently driven through the streets could stop and enjoy a drink. The resulting troughs were once very common items of street furniture in York and elsewhere, but most have disappeared because they were, for example, damaged in traffic accidents or swept away in road-widening schemes. Others have been converted to display flowers while some suffer the indignity of being receptacles for the varied detritus that today's urban dwellers throw away with such casual abandon, especially those items associated with takeaway food and drink.

York still boasts a number of troughs. The choicest is probably that at Clifton Green, built in 1883. Close to Skeldergate Bridge and Baile Hill stands a trough brought into use in 1905. As with many others elsewhere, it was sponsored by prominent members of the RSPCA and it displays the slightly pious legend, 'A Righteous Man Regardeth the Life of his Beast'. Another trough can be found on Lawrence Street.

E

Exhibition Square

This small square fronts the Art Gallery opposite Bootham Bar. It contains a statue, erected in 1911, of William Etty (1787–1849), who was born locally. Etty is probably best known for his depictions of nude human figures, which make up for what some critics call poor draughtsmanship with what others praise as their 'sheen and sinuosity'. Is this damning with faint praise? Surely not. Etty became a Royal Academician in 1828. His antiquarian interests spurred him on to become a leading campaigner against proposals in the 1830s to demolish the city walls. So angry was Etty about the philistines who thought that York would be a much better place without the walls that he threatened to walk from Edinburgh to draw attention to the issue. Perhaps it was a good thing for his shoe leather that in

the end he did not need to do so. He is buried close by in the churchyard of St Olave's, Marygate.

More modern features of Exhibition Square are the fountains, which were turned on for the first time in 1971. They were sponsored by the York Civic Trust.

F

Fire Marks
Fire was a constant hazard in towns containing many close-packed timber-framed buildings, often with thatched roofs and where fires were used for cooking and heating purposes. York suffered innumerable small fires and many major catastrophic outbreaks over the centuries. In theory, each parish possessed some fire buckets and a long-handled fire-hook that could be used to pull burning thatch down.

Fire engines appeared in the eighteenth century. These were horse-drawn and could pump water through hoses much more quickly and effectively than firefighters armed only with buckets. In the eighteenth century many insurance companies appeared on the scene and those who could afford and who paid the premiums were then entitled to the service of a company fire brigade and to financial compensation for losses where fires broke out accidentally. In order to identify those premises that were insured, each company would place its distinctive badge or fire mark in a conspicuous position on the frontage. These were often brightly coloured and had the added effect of acting as advertisements. Early marks were usually made of lead but later examples tended to use copper, iron or tin. Among the leading companies providing these marks were Alliance, Norwich Union, the British Fire Office, Phoenix, the Sun Fire Office and the Union Assurance Society. The Yorkshire Insurance Company was established in 1824 and displayed various views of the west end of the Minster on its fire marks.

Time has not been kind to fire marks. The development of local authority fire services from the 1860s rendered the identification of insured buildings largely irrelevant for the purposes of firefighting. Demolition, rebuilding and redevelopment have led to tens of thousands of fire marks disappearing. Those that survive, albeit separated from the buildings to which they were attached, are cherished by collectors. Even better, though, is when these marks are still *in situ*. York can boast a reasonable number of the latter. Goodramgate, Bootham and Low Petergate can provide examples. With the exception of people like the authors, whose sad lives are only partially compensated for by their interest in the quirky and curious, fire marks go largely unnoticed.

Fishergate Bar
This bar stands at the junction of the present George Street and Paragon Street. Never a major gate in the city walls, its first mention seems to be in 1315, although it was apparently remodelled in the early fifteenth century and was damaged during civil unrest in protest against taxes in 1489. Marks of fire damage can be seen on the jambs of the central arch. Fishergate Bar went out of use as a gateway and in the Tudor period it held both criminals and people considered 'lunatic'. It was reopened as a gate in 1827.

Fishergate Postern Tower

Standing not far from Fishergate Bar at the southern end of Piccadilly, this tower was built in 1505 to replace an earlier structure. Its position enabled one to watch over the River Foss. The arch displays a slot for a portcullis and there is a rather curious-looking seventeenth-century roof, which seems very much out of place.

Five Lions

The arms of the City of York display five heraldic lions of England against the background of the cross of St George. The five lions can be seen on Micklegate and Fishergate bars and on the sign of the Five Lions in Fossgate. The name of this pub is unique. It is thought that Edward III granted these arms to York in the fourteenth century.

Frankie Howerd

By the main entrance to the grandly named Grand Opera House in Clifford Street there is a wall plaque to Frankie Howerd (1917–92), the comedian and comic actor. He was born in York, although he spent little of his life in the city. He suffered from stage fright and had nervous breakdowns, but he developed a distinctive camp style that brought

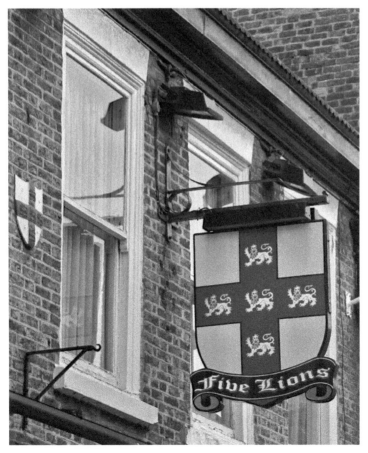

The Five Lions pub sign, Fossgate.

him considerable success. His monologues were full of innuendo and *double entendres* delivered with an air of innocence and characterised by seemingly ad-lib remarks to the audience. For many years he was extremely popular and busy and although his star waned somewhat in his last years, he had become something of a cult figure with his one-man touring shows, finding particularly appreciative audiences among university students.

Fulford Cross

In Fulford Road, opposite the Imphal Barracks and in front of a supermarket, stands the base of a cross believed to have been set up in 1484 to mark the boundary between the parish of Fulford, which was held by St Mary's Abbey, and the City of York. There had been many disputes over grazing rights in the neighbourhood and so demarcation of land ownership was important.

G

Gas Street Lighting

The flammable gas given off when coal is heated was first used for lighting offices at a colliery near Whitehaven in 1765. The first installation of gas for domestic lighting was in 1792. The pioneer use of gas for lighting large industrial works occurred in 1802. By 1809 gas was being used to provide illumination in the streets of London. By 1812, fifty-two towns in England had gasworks. York was not particularly quick off the mark in the use of

Fulford Cross.

gas for street lighting. The first gas street lights were brought into use in 1824. Some gas lights are still in use in the city, notably outside the west front and the south transept of the Minster.

George Hudson Street

The name of this street bears witness to the caprices associated with success and fame on the one hand and failure and disgrace on the other. The original street was opened in 1843. It joined Micklegate and Tanner Row and ran more or less parallel to the river. It made a convenient link from the city centre via Ouse Bridge to the new railway station at Tanner Row and it was also a convenient way of removing an area of ancient and rather unsavoury streets. George Hudson, who at that time could do no wrong, was one of the prime movers in the creation of this street and, in recognition of the role he was playing in the affairs of the city, it was given the name 'Hudson Street'. A few years later, however, his financial affairs collapsed ignominiously around him, ruining many people who had previously worshipped him for his Midas touch. Now that the goose was no longer laying the golden eggs and there were many questions being asked of his business methods, his friends largely abandoned him and his enemies (and a bombastic man like him always had many) triumphantly kicked him when he was down by changing the name to 'Railway Street'. In 1971, when some (but by no means all) of the heat generated by his controversial rise and fall had dissipated, the name changed again and became what it is today – George Hudson Street.

Ghost Adverts

York has a number of 'ghost adverts', the best-known of which is for Bile Beans (*q.v.*). Below is one for John Smith's beers, which are brewed down the road from York. The location is Heslington Road.

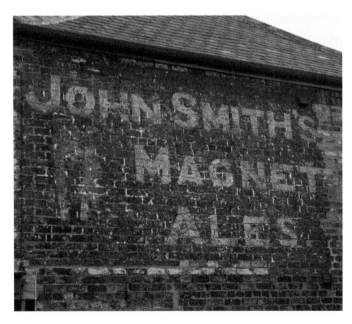

Ghost advert,
Heslington Road.

Ghosts

It is not necessary to believe in ghosts. The authors, however, believe that it is necessary not simply to scoff at the whole idea. What can best be described as supernatural phenomena have occurred too frequently throughout human history to be dismissed out of hand. Those who study these phenomena argue that they are often associated with violent, tragic or traumatic events. Of these, York has had more than its fair share and it is therefore not surprising that there people who claim that it is the most haunted place in the British Isles. It has to be said that there are various other, usually ancient, towns or cities about which the same claim is made.

We are not sure that ghosts really qualify as street furniture, but since they seem to be a part of the city's fabric, we've decided to include them. Among the best-known haunted sites in York are the Treasurer's House (*q.v.*); the Minster; King's Manor; the environs of St Mary's Abbey; Clifford's Tower; the Cock and Bottle pub in Skeldergate; the Golden Fleece, Pavement; the Black Swan, Peaseholme Green; the York Arms, High Petergate; and Ye Olde Starre Inn, Stonegate.

Golden Bible

Protruding from the front of No. 35 Stonegate – York's premier tourist street – is a golden Bible. This is an old shop or trade sign dating back to the eighteenth or nineteenth century and it supposedly hung above the city's leading bookshop of the time. Shop signs are increasingly rare these days, yet the three brass balls of the pawnbroker are seen quite frequently and, if anything, have probably increased in numbers in recent years, given the hiccups of the economy. However, chemists' use of giant pestles and mortars or glass carboys containing coloured liquid is on the decrease, as is the white pole with symbolic bloodied bandage that was once so frequently used by barbers.

Grape Lane

This short street runs between Low Petergate and Swinegate in the heart of the old city. Its name is basically a Victorian euphemism. Our medieval ancestors were rather more prepared to call a spade a spade than later generations and this street was once called 'Gropecunt Lane'. It is likely to have been a place where prostitutes touted their wares and paid-for sexual couplings took place in the open air, or possibly in 'stews' or brothels. It is one of the ironies of twenty-first-century living that people would now recoil with horror at the idea of giving such a name to a street and yet hardcore pornography is one of the largest and most profitable arms of the entertainment industry.

Green Men

The authors are fascinated by green men. York has some examples, both internal and external. As mentioned, All Saints, North Street, can boast several on roof bosses in the nave and aisles. All Saints, Pavement, displays one on a fifteenth-century lectern; the Guildhall has one on a roof boss in the committee room; St Denys has twelfth-century foliate heads on the south doorway; St Margaret, Walmgate – now the National Centre for Early Music – displays them on the south doorway and St Mary, Castlegate, which is now a museum, has one on the south face of the tower.

Guy Fawkes

Born in York, Guy Fawkes (1570–1606) converted to Catholicism as a young man, after which he served in a number of military campaigns on behalf of the King of Spain, whose cause at that time was synonymous with Roman Catholicism. He won many commendations for his bravery. A fanatical Catholic, he found his co-believers suffering considerable discrimination and persecution when he returned to England. A group of disaffected Catholics, mostly minor members of the land-owning classes, concocted a plot to blow up James I and almost all the country's political elite at the State Opening of Parliament scheduled for 5 November 1605. They thought that if they then installed a replacement monarch who, presumably, was a Catholic or at least sympathetic to the believers of that faith, they would end discrimination against Catholics. They had one or two candidates lined up for this honour, although these potential pretenders were not privy to the conspiracy.

Clearly it was a hare-brained as well as a morally flawed scheme. How they thought that blowing up the Palace of Westminster and killing or maiming several hundred people would do God's work and advance the cause of Catholicism was not explained. How they thought they could get away with it also defies explanation. Most of the conspirators may have been fairly fanatical, but they were certainly not particularly bright. Guy Fawkes, however, was a man of a different kidney. He joined the conspirators at a comparatively late stage and was only a minor player. It may well have been that he was the fall-guy

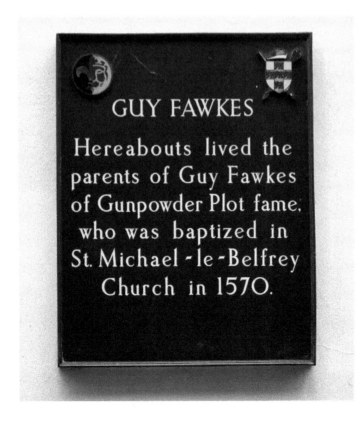

A plaque in Stonegate makes an equivocal claim.

whose known courage and singleness of purpose meant that he volunteered for (or was volunteered to) perform the most hazardous part of the plot, which was, of course, setting off the explosion. The story of how the existence of the plot was discovered is beyond our remit. Suffice to say that Fawkes was found in the undercroft below Parliament literally sitting on more than enough explosive to do the job several times over. He was of course arrested and questioned and when he refused to implicate his fellow conspirators, he was stretched on the rack until he became more co-operative. Even then the authorities found it hard to extract the information they needed. It is likely that even his inquisitors would have had a grudging admiration for his courage, as well as revulsion for what Fawkes was prepared to do in support of his religious beliefs. He was, of course, eventually hanged, as were many of his fellow conspirators.

There is uncertainty as to exactly where Fawkes was born, although it was almost certainly in the High Petergate and Stonegate area of the city. Young's Hotel on Petergate claims to be the birthplace of Fawkes. Such a claim is probably good for trade even if it is not totally substantiated. We know that he was baptised in the church of St Michael-le-Belfrey close by in 1570 – a plaque on the building informs us of the fact. He was educated at St Peter's School and is probably one of their best-known alumni, if for all the wrong reasons. To this day the school refrains from celebrating his fame; neither does it build a bonfire and burn an effigy of him on Guy Fawkes Night.

H

The Hansom Cab

This is the rare name of a pub in Market Street that commemorates Joseph Hansom (1803–82). He was born at No. 114 Micklegate – which is now the 'Brigantes' pub – and was brought up in the city. He began an architectural apprenticeship and subsequently moved away from York. His best-known building is probably Birmingham Town Hall, which, unusually for him, is a fine example of the Neoclassical. He most frequently worked in the Gothic Revival style. In York itself, he was responsible for St George's Catholic church in George Street, off Walmgate. He founded a journal called *The Builder*, which continues to this day, although it is now called *Building*.

His name will almost certainly be most familiar to readers because of the patent safety cab, better known as the hansom cab, which he designed and which became phenomenally successful. It was a horse-drawn hackney cab with various inbuilt safety features, and it became an almost ubiquitous item on the streets of towns and cities throughout Britain and indeed elsewhere overseas. An example is preserved in the Castle Museum.

Holy Trinity, Goodramgate

This small and ancient church stands as a haven of tranquillity right in the bustling centre of the city. It is most easily accessed through an attractive eighteenth-century brick arched gateway in Goodramgate. This is a church for those who prefer the humble and more vernacular parish churches of England to such buildings as the Minster, which, for all its undeniable magnificence, stands as a monument as much to temporal power and

Holy Trinity, Goodramgate.

realpolitik as to spiritual values. Holy Trinity was first mentioned in 1082 and its charm for the visitor lies in its being the only one of York's ancient churches fortunate enough to have evaded the heavy-handed restorations for which the Victorians are famous. In this book we make little mention of the interiors of York's buildings, but the charm of both the exterior and particularly the interior of Holy Trinity is undeniable.

Holy Trinity, Micklegate
The oldest part of this building is the nave of a Benedictine priory dating back to the latter part of the eleventh century. The only stocks to be found in York are just inside the gate of the churchyard. In medieval times, great store was set by the idea that justice should not only be done but be seen to be done. In 1405 it was decreed that every parish should have stocks into which petty offenders were placed by way of punishment. These devices had the great advantage of being cheap to install and maintain and required little or no supervision. The miscreant was held up to public ridicule and shame – a central tenet of medieval penal thinking – and they acted as an example to deter other would-be offenders. The nature of the offence for which he was being punished would usually be called out. Stocks provided entertainment for the local population, who could express their disgust with the offender and his crime by verbal insults or by throwing missiles at him. Being unable to move or protect himself, he was a sitting duck. On occasion it was even known for people to urinate on the occupant, but it was more common to bombard him with rubbish, rotting matter and other kinds of repulsive ordure. Throwing stones was officially disapproved of. Sometimes, however, the offender might have been a popular figure locally who had fallen foul of authority rather than having done something the crowd disapproved

The stocks at Holy Trinity, Micklegate.

of and then the bystanders would chat in a friendly fashion and give him their support. If his crime was something regarded as unacceptable, he could have a rough time indeed. It was usual for him to occupy the stocks for a set time and this could itself be unpleasant if it was cold or wet or if the sun was shining directly on him. He might add to his humiliation by urinating or emptying his bowels, and the least of his worries were the cramps that he would experience through being in one position for such a long time. Traders who gave short measure were often placed in the stocks. They could always expect a hard time.

This church is well known for its ghosts. Not content with just the one spectre, Holy Trinity boasts four. They are a small girl, her mother, her nurse and, a little less frequently, her father. Large numbers claim to have seen these apparitions, either at the east end of the church or outside in the churchyard, and in both cases often in broad daylight.

I

Icehouse

Close to the city walls near Monk Bar is a small structure of red brick. It is an icehouse. It may be stating the blindingly obvious, but an icehouse is a building designed for the storing of ice. A large mass of ice packed together has a relatively small surface compared with its cubic capacity and this has the effect of greatly slowing down the melting process. Placing ice within insulated walls and under a roof further prolongs its life.

The icehouse, St Maurice's Road.

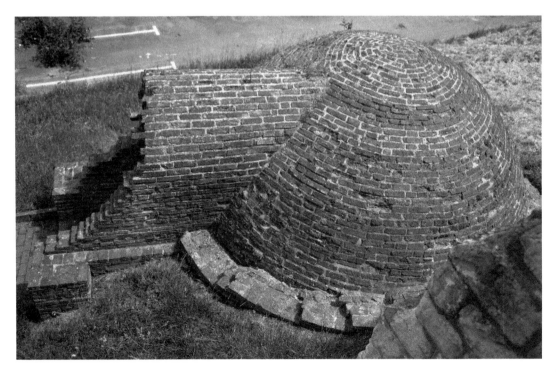

The icehouse from above.

Until refrigeration became generally available, people lived on seasonal fare and supplies might be abundant in one season and short the next. A lot of food was therefore dried, salted, pickled in vinegar or alcohol, smoked, potted, or preserved in sugar syrup. Especially for the poor, this could mean monotonous and rather unappetising fare, at least for a significant part of the year.

The first British icehouses seem to have been brought into use around 1620 and they probably stored winter ice for chilling desert dishes and cooling wine on warm summer days. These buildings were luxury items available only to very rich families, who soon discovered that icehouses could be used to prolong the life of various perishable foods. By the mid-nineteenth century, most country houses had one or more icehouses on their estates, often subterranean, while some town houses had them as well, frequently in the basement. Icehouses largely went out of use in the twentieth century, as ice was imported on a commercial scale, from Norway and the USA in particular.

Imphal Barracks
The citadel of these barracks is an eye-catching if exceptionally ugly building standing on Fulford Road and bristling with closed-circuit TV cameras, which provide a good reason for us not taking a picture of it. The name commemorates the Battle of Imphal, which lasted from March to July 1944 and was part of the Burma Campaign. Imphal was the capital of the north-eastern Indian state of Manipur and it was around Imphal that the Allies repelled a determined Japanese thrust to invade India. Heavy losses were inflicted on the enemy and the battle was a major turning point in the Southeast Asian theatre of the Second World War.

Ingram's Almshouses
These almshouses date from 1640 and were paid for by Sir Arthur Ingram, who provided them for the housing of York's needy widows. It is likely that even then he seriously underestimated the numbers of these indigent ladies by only making provision for ten of them. The almshouses are located in Bootham between Bootham Bar and Clifton.

Dr Johnson once uttered the immortal words, 'A decent provision for the poor is a true test of civilisation.' The origins of almshouses lie with the monasteries, which took on the Christian duty of caring for people in need. Doubtless, almshouses have been established by the well-to-do out of genuine philanthropic concern. Others may have been the result of the donor seeking personal salvation or ostentatiously wanting to show off the fact that he had enough wealth to spare for such things. Plaques and other reminders of the largesse of the founder are often prominently displayed on these buildings.

Almshouses have a number of alternative names. Some are called 'hospitals' (a reference to the fact that they offer hospitality), 'colleges' (referring to their communal aspect) 'bede houses' (using an old English word meaning that prayers were said for the founder's soul) and French or Latin variations of 'God's House'. More recently, they tend to have been called 'homes' or 'cottages'.

The founders or subsequent administrators of almshouses were usually rather fussy about who was admitted. Only the 'deserving poor' had much chance of taking up residence. 'Deserving' in this context does not mean that they deserved to be poor, although of course

in Christian terms, poverty was an exalted state. It is unlikely that it was seen as such by the poor themselves. Rather, 'deserving' means that they were in reduced circumstances through no fault of their own such as fecklessness or insobriety. People described as 'debauched' or 'disorderly' were unlikely to be allowed admission. Some required applicants to prove they were, or at least had been, 'industrious'. Once an applicant had taken up residence, he or she was likely to be subject to a rigorous set of rules regarding their conduct. This often involved compulsory attendance at communal prayers, which usually involved an expression of gratitude for the munificence of the founder or the trustees.

In York the original building of Ann Middleton's Hospital in Skeldergate has become a hotel while the adjacent Terry Memorial Homes are a brass-rubbing centre.

J

Jacob's Well
This is a timber-framed house, probably dating from the fifteenth century, located in Trinity Lane off Micklegate. In the nineteenth century it was a pub called the Jacob's Well Inn; it was extensively restored in the first decade of the twentieth century. It has an odd-looking canopy over the door. This canopy is probably late-fifteenth-century and was removed from a building, probably also a pub, elsewhere in the city. Apparently this kind of canopy was once common in York.

Jacob's Well, Trinity Lane.

The biblical Jacob was by no means a pleasant character. He was a son of Isaac and is described in Genesis 25–50 as the father of the Jewish nation. As a boy, he traded his brother Esau for a 'mess of pottage' in order to obtain the latter's birthright and then duped his father into giving him his blessing by donning a hairy disguise. He then fell in love with Rachel and spent seven years desperately trying to win her affections, but he was tricked and was given Leah instead. He still carried a torch for Rachel, however, and seven years later he managed to win her after all. It is only to be hoped that after such a prolonged wait Rachel did not prove to be an anticlimax. Jacob returned to his family, wrestled with an angel, and was then given the name Israel.

After all this, the authors *hope* that it was this Jacob whose well is commemorated in Trinity Lane.

Jubbergate

This is the truncated remnant of a street that once ran from the Shambles to Coney Street but which was divided in 1836 when Parliament Street was built. The curious name, although it has evolved over the years, refers to the fact that it ran through a concentrated area of Jewish settlement.

Judges' Lodgings

On the north side of Lendal, the former Judges' Lodgings can be seen. This is a large and imposing early-eighteenth-century town house that, for about 180 years, was where the circuit judges resided while the assize courts were being held in York. The size of the building suggests that the judges did not stint on their enjoyment of the good things in life that they felt were commensurate with the dignity of their office.

K

King's Arms

This old pub on King's Staith, very close to Ouse Bridge, is known to have been an inn for almost 230 years, although the building is actually older. The king referred to is Richard III, well liked locally despite demonisation by Shakespeare and his consequent bogeyman status. Now crowds of drinkers bustle outside on warm, sunny days where once watermen, stevedores and porters would have been busily working. This was the site of the most important quay in the days when York was a major inland port. The pub's position makes it highly vulnerable to the frequent floods on the Ouse; wisely, the cellars are upstairs. The pub is generally believed to be Britain's most flooded pub. It is a tied house belonging to Samuel Smith's Old Brewery at Tadcaster. One oddity of the brewery's pubs is that they do not show the name 'Samuel Smith' on the outside and promotional material for the company is kept to the barest minimum.

King's Manor

Standing close to the art gallery in Exhibition Square, King's Manor originated as the Abbot's House of St Mary's Monastery. It was rebuilt in brick in the 1480s and the windows

inserted at that time provide the earliest known example of terracotta as a building material. After the dissolution of the monasteries, from 1561 it found a new use as the home of the Lord President of the Northern Council, and of the council itself, and it remained in use for about eighty years in that capacity. Henry VIII and James I stayed here and during the Siege of York in 1644 the building served as the Royalists' headquarters. It has seen many uses and structural modifications over the ensuing years.

King's Square

This small square between Petergate and the Shambles is on the site of Holy Trinity church. Its outline can be roughly traced in the shape of the square and some gravestones are also visible.

Knavesmire

Also known as Micklegate Stray, the Knavesmire is the largest of the city's areas of open land on which the freemen of York enjoyed the right to graze their cattle. These are now preserved as open spaces in perpetuity and York has been very lucky in being able to keep much of the land in this way; similar commons close to other towns elsewhere were gobbled up for building development in the nineteenth century (Nottingham is an example). The Knavesmire houses the city's racecourse. It is thought that the Romans based in York probably enjoyed spontaneous racing, but it was Henry VIII who was crazy about the turf and who revived the sport and made it better organised. In the 1730s a new, purpose-built course opened on the Knavesmire. The origin of the name is the Anglo-Saxon word 'knab', which refers to a person of humble circumstances who would have tried to eke out a frugal existence on this flood-prone pasture.

Part of the Knavesmire was known as 'Tyburn', an allusion to London's major place of public execution from the twelfth century up to the year 1783. As with Tyburn in London, this was where many executions took place, including considerable numbers of Catholic martyrs in the later years of Elizabeth's reign between 1582 and 1603. A modern stone on Tadcaster Road marks the spot where innumerable poor devils kicked out in agony, often to the great amusement of the watching crowds.

The most notable execution of a convicted felon was probably that of Dick Turpin on 7 April 1739. We have already examined the myth about Turpin, Black Bess and the ride from London to York (see page 30). Another myth is that Turpin was handsome, courteous and dashing with a likeably roguish and roving eye. These characteristics, it was averred, made him irresistible to women who set out on coach journeys *hoping* that they would be intercepted by Turpin. They knew they were safe, so the myth went, because Turpin would never raise his hand against a woman and, what is more, he was always punctilious, ever the gentleman, and almost apologetic when he robbed travellers of their valuables. Nothing could be further from the truth. Turpin was a vicious and violent thug prepared to shoot anyone who got in his way. He wasn't even handsome – his face was deeply pockmarked, probably the result of smallpox. Most of his inglorious career was spent around Essex and Hertfordshire, but eventually things became too hot for him there and so he decided to move to a part of the country where he was not known. He ended up in Lincolnshire under the name 'John Palmer'. He was a horse-dealer, the equivalent of today's second-hand car

salesmen. However, he was apparently respectable and seemed to have enough money to ape the style of a country gentleman. The story of what happened in 1738 is not quite clear. He either shot or stole a fine gamecock, for which he was arrested.

He was unable to provide the money required for release on bail, and so he was kept in a house of correction while investigations were undertaken. These revealed that he answered the description of a man wanted in connection with a series of cattle-rustling and horse-stealing offences in Lincolnshire and Yorkshire. Rumours began to circulate that he was actually none other than the wanted desperado Turpin, who had apparently vanished without trace back in the south of England. Wisely, the authorities placed him in the gaol at York Castle. While he was there, he made what proved to be a fatal mistake: he wrote to one of his relations, asking him to provide a character reference for the forthcoming trial, but he omitted to pay the postage and his relation, not recognising the writing, refused to pay. The letter then ended up at the post office in the Essex village of Hempstead in which Turpin had been brought up. By the merest of chances the handwriting, which was apparently highly distinctive, was recognised by Turpin's former schoolmaster. His cover had been blown! England's most notorious highwayman lay in York Castle facing the mundane charge of horse-stealing. It was, however, a capital offence and on being found guilty, Turpin was condemned to death. Ancient proverbs about it being as well to be hanged for a sheep as for a lamb come to mind, and here was Turpin, the infamous highwayman and murderer, about to be hanged for stealing a horse.

Turpin conducted himself with considerable sangfroid, both in the condemned cell where large numbers of distinguished visitors came to see him and at the Knavesmire where huge crowds turned out to be entertained by watching the notorious highwayman's death. His body, still warm, was cut down and first of all taken to the Blue Boar Inn in Castlegate. Business was brisk that night. The next day, Turpin was buried in the churchyard of St George's. An attempt was made by 'resurrection men' to disinter the cadaver for sale to teachers of anatomy and surgery at some distant medical school. The miscreants involved were seen and chased and, becoming hard-pressed, they unceremoniously dumped Turpin's uncomplaining corpse, and ran. Turpin was soon back in his grave, but this time his inert form was covered with quicklime to render it useless for any further attempts at 'resurrection'.

It is odd that the Knavesmire does not even boast a commemorative plaque recording its gruesome past.

L

Lady Ann Middleton's Hall

Also known as Dame Middleton's Hospital, this stands on Skeldergate and was founded in 1659. Anne Middleton was the wife of a mayor of York. It was a fine town residence and was for many years a hospice for the widows of York's freemen. The present main building is a nineteenth-century reconstruction of the original building and sports a statue of Anne wearing a quaint hat. It is now a hotel.

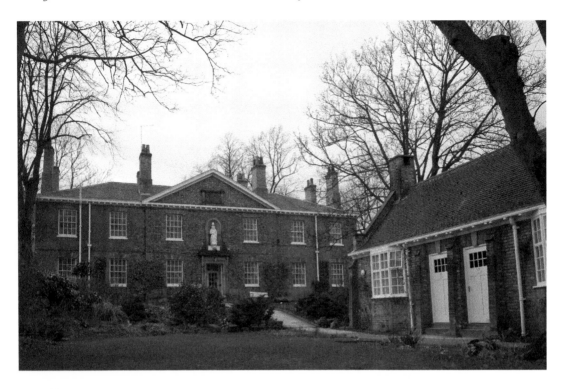

Above: Dame Middleton's Hospital, Skeldergate.

Left: A 'coat of alms' at Dame Middleton's Hospital.

Lady Row, Goodramgate

This understated row is said by some to be the oldest surviving example of timber-jettied building in England. The jetty, or overhang, dates from the fifteenth century. In the marvel of ingenious design that is the medieval timber-framed building, the floor joists were heavy beams laid flat across the house. To avoid the springiness that might occur with lengthy joists, the upper floors were constructed to overhang the storey below and to rest on the projecting joists. This thoroughly scientific system was based on weighting the overhang of the joists with the upper wall, thereby strengthening them, making them in effect internal as well as external brackets. The bracket part is subject to stresses opposite to those acting on a joist, and the strain is thereby largely removed. The use of jetties was therefore mainly a constructional expedient rather than having much to do with minimising the ground area of the building in order to reduce tax liability.

The buildings of Lady Row were originally occupied by a college of priests based at the adjacent Holy Trinity church. They were bought by the Corporation of York after England's monasteries were dissolved in the late 1530s. Some of the southernmost houses were demolished in the 1760s to allow for the making of a new entrance to the churchyard of Holy Trinity, and they have been refurbished and renovated on a number of occasions. Lady Row is a remarkable survivor and a great asset, even in a city with so many buildings of historical and architectural merit.

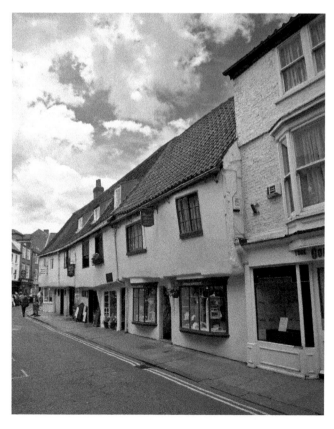

Lady Row, Goodramgate.

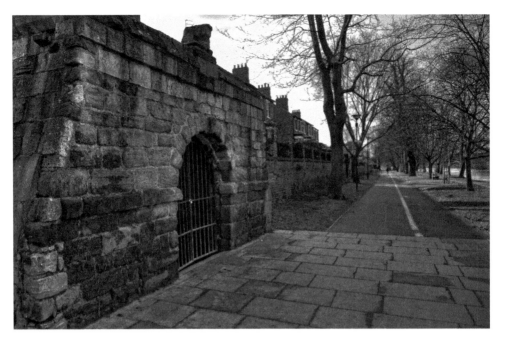

Lady Well.

Lady Well

Also known as the Pikeing or Pickering well, Lady Well stands on New Walk, a short distance downriver from the Blue Bridge. It is the work of the notable local architect John Carr (1723–1807), who was usually referred to as 'Carr of York' and who did much work of high quality throughout Yorkshire. Water from this well was supposed to be efficacious for a variety of ailments of the eye. As often happens, the elegant building became neglected, but it has recently been restored. The appearance of Lady Well suggests that it is a spring rather than a well. At one time it was accompanied by a grotto.

Leetham's Mill

This is a major industrial building standing close to the city centre by the River Foss and completely dominating its surroundings. It was part of an enormous flour mill that began operating in 1861. Other buildings were added at the site, where, by 1911, over 600 workers were employed. Supplies of grain were brought in by barges on the river. Part of the site came under the control of Rowntree & Co. in 1937 and the building itself is now called 'Rowntree Wharf'. Predictably, it contains offices and residential apartments.

Leetham's Mill really is an extraordinary building, thrusting itself aggressively forward at the junction of the Foss and Wormald's Cut. It was designed by William Penty of the well-known local architectural practice Penty & Penty and was built in 1895. Its tall tower is crenellated and has false machicolation. These architectural motifs are perhaps a gesture towards York's glorious heritage of venerable buildings, but the whimsy sits in somewhat uneasy proximity to a heavy-duty hoisting apparatus that protrudes at right angles from the tower just below its crenellations.

A view of Lendal Bridge, looking north across the Ouse.

Lendal Bridge

When the bridge opened in 1863, it provided the city with another much-needed river crossing. A ferry had operated close by since medieval times, but it was becoming increasingly inadequate and so the Corporation of York decided that a bridge was needed, particularly to improve access to the railway station. It took a long time for the planners to decide what kind of bridge was needed, but eventually they plumped for a structure designed by William Dredge. Work on this bridge started in 1860 but it collapsed while being built, causing the unfortunate death of five workmen. Acting with a sense of urgency, the corporation cast Dredge aside and chose a new design by Thomas Page. This bridge was completed in 1863. Page was something of a pontine virtuoso. He not only designed Lendal Bridge and Skeldergate Bridge in York, but also rose to national fame as the designer of Westminster Bridge. This was officially opened not long before Lendal Bridge and although it obviously spans a much wider river, there is a distinct family resemblance in terms of the constructional ironwork, Gothic detail and decorative lamps.

Dredge's incomplete structure was appropriately dredged up from the river and advertised for sale. It might be thought that not many people would want a part of a bridge, especially one that had suffered failure and had spent some time submerged in mud on the bed of a river. However, Scarborough Council snapped it up at a bargain basement price and it was incorporated in what became the well-known Valley Bridge. This may have been gratifying to the local authorities concerned, but it left the ferryman extremely disgruntled. No one required his services anymore, but the corporation gave him a golden handshake and a horse and cart, whereupon he trudged away out of history and into the great blue yonder.

Lendal Bridge was a toll bridge until 1894. The cute little toll houses are still there, having found alternative uses.

Lendal Tower

This stone tower stands next to Lendal Bridge on the north bank of the River Ouse. Although it was originally built for defensive purposes, in the seventeenth century it was adapted to extract water from the Ouse and pump it through wooden pipes to subscribers in the city. The tower continued to function as York's waterworks until 1836 or 1846, depending on which account is read.

Little Ease

If rest and freedom from discomfort and anxiety are ideas associated with 'ease' then there would have been precious little of these for any poor soul incarcerated in Little Ease. This was a minute prison cell in Monk Bar – only 5 feet 3 inches in diameter. It currently houses the Richard III Museum. In 1594 it housed local recusant Alice Bowman.

The word 'recusant' comes from a Latin stem and means something like 'refusal'. In the sixteenth century, the word came to be associated with those Roman Catholics who, despite being legally required to do so, refused to attend services of the Church of England. Recusants faced an increasingly savage range of penalties for their obstinacy. These included fines, forfeiture of property, life imprisonment, banishment and death. The body of legislation concerning the offence of recusancy only began to be repealed after 1778.

M

Mad Alice Lane

This is a snickelway running from Swinegate to Low Petergate. It supposedly has its wonderful name because a former resident named Alice was hanged at York Castle in 1825 simply on account of being considered mad. It has an alternative name – Lund's Court.

Mansion House

On the south side of St Helen's Square stands the Mansion House. Various dates around 1730 are given for the opening of this building. It was designed to be the official residence of the Lord Mayor during his year of office and it remains such. It was actually the first building dedicated for such use in England, pre-dating that for the Lord Mayor of London by several years. Those in the City of London, Doncaster and York are the only three mansion houses in Britain.

Memorial Gardens

This open public space at the junction of Station Avenue and Leeman Road contains the city's major war memorial. It was designed by Sir Edward Lutyens, best known for the Cenotaph in London's Whitehall, and commemorates the fallen of the two world wars. The memorial is in the form of a tall, thin cross. Also to be seen is a memorial to those British service personnel who died in the less-well-remembered Korean War in the early 1950s.

The creation of postwar memento mori is not a modern development. The Romans, for example, had cemeteries displaying military mementos. After the Great Fire of London in 1666, the Royal Hospitals at Greenwich and Chelsea were built, not just as havens for needy war heroes but as statements of the growing sense of nationhood in England, encapsulating the perception that those who give their lives in wartime should be publicly remembered. The Victorian age was the heyday of British imperialism; the armed forces were engaged almost continuously in 'little wars' – to conquer and win new territory, to fend off rival imperialist powers intent on doing the same thing, or to suppress nationalist and other rebellions in Britain's 'possessions'. Over the decades, the death toll was considerable among the (mainly) young men of the Army and Royal Navy. In practical terms it was often impossible to bring the deceased back to Britain for burial. So the concept of public memorials developed as a way of vicariously recognising the sufferings and sacrifices that had been made. In a society riven with inequality and social injustice, these memorials were intended to act as symbols of national unity and common struggle across the classes. Others saw them as icons of jingoism and xenophobia.

Death tolls rose to unprecedented heights among the largely conscripted soldiers on the Western Front during the First World War. Serious questions were being raised about the continuing carnage, and it was decided that battlefield burials would do less damage to morale than bringing the body bags back to Blighty. In 1918, at the end of the war, the Government encouraged local authorities to find ways of raising money for memorials to be erected locally. Although the Government was not prescriptive as to the form these memorials should take, it was intended that they would demonstrate communal sadness about the loss of so many young men rather than signifying any kind of triumphalism. Huge numbers of war memorials were built over the following period. When the Second World War ended in 1945, there was far less of an urge to commemorate the dead of that conflict, the feeling being that resources could be put to more appropriate use in physical reconstruction and the creation of a new and hopefully better society.

Merchant Adventurers' Hall
This very fine guildhall with its attractive garden between Fossgate and Piccadilly was built by the Guild of Our Lord and the Blessed Virgin in the late 1350s. Eventually, in 1581, the Guild of Merchant Adventurers was formed by the merger of the Guild of Our Lord and the Blessed Virgin and the Guild of Mercers; they went on to cultivate a monopoly of the export and import of many kinds of goods through York, especially wool and woollen cloth. They developed a very strong position in York, where they could, and did, prevent anyone from opening a shop or trading without their permission.

Micklegate Bar
This has always been regarded as the most important of York's gateways. It contains fabric from many periods and even recycled Roman stones. The façade bears various heraldic devices, including the royal arms of Edward III and the city arms. It is topped with figures of knights. These were erected in 1950 as replacements for much earlier ones which had become badly eroded.

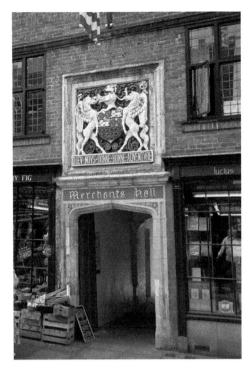

Left: The entrance to the Merchants Adventurers' Hall, Fossgate.

Below: Micklegate Bar.

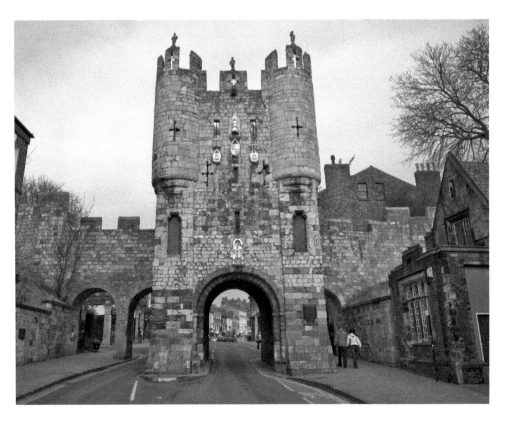

Because Micklegate Bar was the main entrance and exit to York from and to the south and especially London, it was very busy and it became a favoured place for the display of the severed heads or other bodily parts of traitors and rebels – those who would now be called political prisoners. The purpose of these gory trophies was, of course, to act as a deterrent and a silent sermon on the fate of those foolish enough to defy those who possessed power. These heads were exposed to the elements and to the carnivorous attentions of fowls, and after a time they either fell off their spikes or were removed. This was a shame, because if they had become permanent fixtures, they would provide a visual display of the more turbulent aspects of York's history. Among those whose heads adorned the bar were Sir Henry Percy (better known as Hotspur) in 1403, Richard, Duke of York in 1460, various leading Lancastrians captured at the Battle of Towton in 1461, the Earl of Northumberland in 1572, anti-monarchists in 1663, and assorted Jacobites in 1746.

Millennium Bridge

Crossing the River Ouse and joining the Fulford and Clementhorpe districts of York is this beautiful bridge in a thoroughly modern idiom. Made of stainless steel, it opened in April 2001. It is not only a structure appreciated for its utility – it has improved access to the south of the city – it has also come to be regarded as a tasteful addition to the landscape.

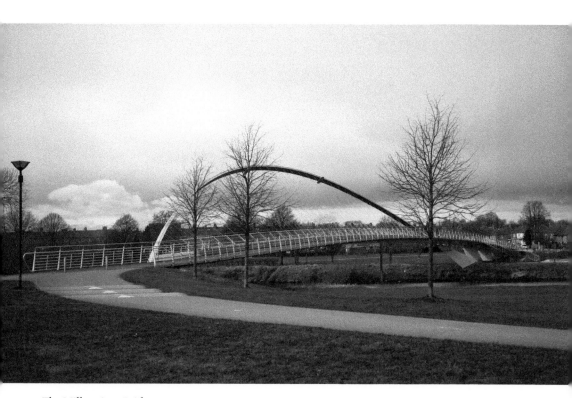

The Millennium Bridge.

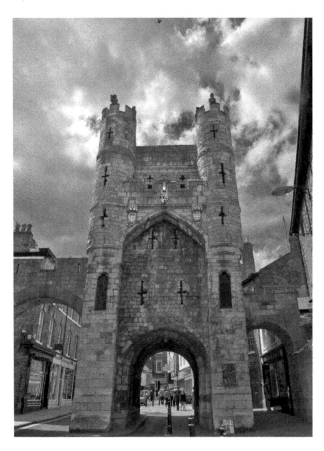

Monk Bar.

Monk Bar

This was originally called Monkgate Bar and is the highest and strongest of York's medieval gateways. It was indeed a powerful bastion, designed as a self-contained stronghold capable of withstanding a serious and prolonged attack. The lower floors are stone-vaulted and therefore fireproof, and as with the keeps or donjons of many castles, the interior design was such that each floor would have to be fought for by attackers and in many ways the advantage would be with the defenders. There are loopholes through which arrows could be fired, gunports for firearms and traces of 'murder holes' through which missiles and boiling water, for example, could be dropped on attackers. There is a portcullis, which can still be worked. A barbican has been removed, as is also the case at Bootham Bar.

The coats of arms are those of the Plantagenet kings. The uppermost storey was added in 1484 by Richard III and now contains a museum dedicated to that much-maligned monarch. There is also a prison called the Little Ease (*q.v.*), in which defiant Catholics were housed in the reign of Elizabeth I.

Mulberry Hall

This is a particularly fine timber-framed building dating from 1434 that has been a shop in Stonegate for well over 200 years.

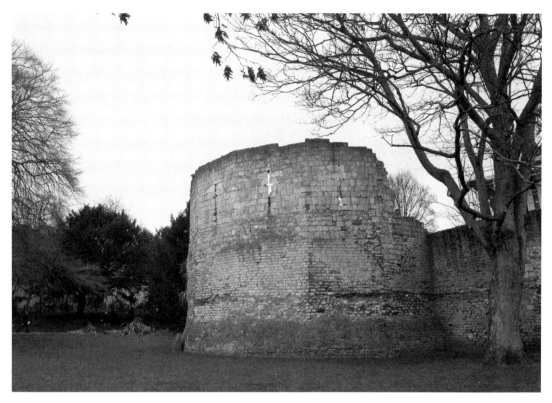

Multangular Tower, Museum Gardens.

Multangular Tower

Located in the Museum Gardens, this is the last surviving defensive tower of the Roman period and marks the western extremity of the fortress of that period. It was built around AD 310 and has been much altered over the centuries. The part of the fabric that is Roman constitutes the bottom 20 feet. The higher portion is of the thirteenth century. 'Multangular' is an appropriate word, for the tower has ten sides.

Museum Gardens

York is extremely fortunate to possess such a large area of attractive parkland greenery so close to the city centre and abutting the Ouse. It has a concentration of attractions that includes the Yorkshire Museum, the observatory, the ruins of St Mary's Abbey, St Leonard's Hospital, and the Multangular and Anglian towers and the Hospitium, which is the timber-framed former gatehouse of the abbey. Peacocks strut around in their self-important way, emitting irritating screeches, and grey squirrels guarantee themselves an almost endless daytime supply of tasty titbits by playing 'cute'. These gardens are hugely popular.

Originally the intention was that the gardens would just be for the delectation of members of the Yorkshire Philosophical Society, but the public was allowed in on payment of an entrance fee from 1835. In 1961 York City Council took over the running of the Museum Gardens and admission since then has been free.

N

New Earswick

Three miles north of York stands New Earswick. This settlement of 150 acres was started in 1902 and is of interest from the point of view of social history, town planning and the concept of garden cities. In 1899 Britain had been shocked by the publication of Benjamin Seebohm Rowntree's report on the widespread poverty and bad housing in York. New Earswick was the brainchild of Benjamin's father, Joseph Rowntree. He almost certainly took some inspiration from his fellow Quaker George Cadbury, who was in the process of creating Bournville close to his chocolate factory on the fringe of Birmingham.

As Quakers, both Rowntree and Cadbury had a moral conviction that successful industrial enterprise, pleasant environmental, living and working conditions and contented workers were not mutually exclusive concepts. Along with W. H. Lever's Port Sunlight on the Wirral, these developments took employee housing into a new phase. They represented a fresh vision of how industrial life could be transformed in a planned, controlled environment combining the advantages of town and country with largely rural surroundings. It was believed that well-built houses in pleasant and spacious surroundings could still produce rent income that would provide a modest return on the investment. It was never intended that the housing would be let exclusively to Rowntree's employees and their families.

The planner of New Earswick was Raymond Unwin and the architect Barry Parker – both were later involved in the creation of the garden cities at Welwyn and Letchworth in Hertfordshire. They borrowed some of the planning concepts integral to the work of 'middle-class' architects such as Voysey and Webb, including the requirement that living rooms should face the sun, whether this meant arranging them at the front or the back of the house. With this in mind, there was no place for traditional narrow-fronted workers' housing. Wider frontages allowed the inhabitants enough space to take advantage of the sunlight. Part of the vision was that every garden would have fruit trees and enough space to grow vegetables. New Earswick was to be a garden village equipped with a range of social facilities that it was believed would foster a sense of community.

Fun has often been poked at the garden city movement for having what was described rather tartly as a 'pantomime vision of bucolic England', with houses tending 'to look like Anne Hathaway's cottage with the electricity laid on'. Clearly the movement could not provide a complete solution to the housing issues of an industrialised and urbanised society, and it was naïve to expect that it would. However, it is true that garden cities – or, in the case of New Earswick, a garden *village* – developed concepts that have continued to exert an influence on housing and town planning in the twenty-first century.

North Eastern Railway Headquarters

The year 2006 was the centenary of the opening of arguably the most remarkable railway company headquarters anywhere in Britain. This building, the former head office of the North Eastern Railway, lours over Station Road and Tanner Row, dominating its immediate surroundings almost as completely as does the Minster, which is not far away on the north side of the river. The North Eastern Railway was an amalgamation of a number of smaller companies and became the fourth largest of the pre-grouping British railway companies, an

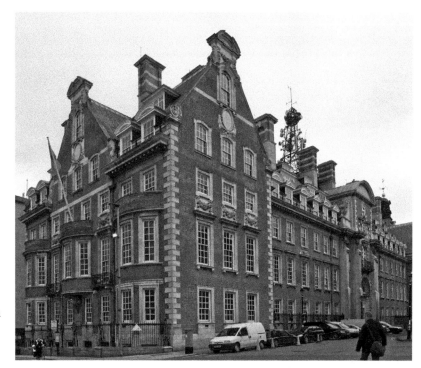

The former
North Eastern
Railway
Company
headquarters.

efficient business with an almost complete monopoly on railways betwen the Hull–Leeds line and Berwick-upon-Tweed in Northumberland. It has to be said that the ostentation and opulence of the company's headquarters stood in remarkable contrast to the frugal facilities on offer at some of its small country stations and halts.

It is perhaps difficult to categorise the architectural style of this building – 'Indeterminate Eclectic' might be a starting point. There are dashes of the very influential Richard Norman Shaw (1831–1912) who was associated with the so-called Queen Anne Revival. There is something of the Dutch Renaissance about the gables. The architect was William Bell and there are internal and external embellishments by Horace Field. The pedestrian gazing up will have his eye caught by the North Eastern Railway 'coat of arms' on an elaborate cartouche. This device, heraldically incorrect, consists of motifs from several of the major places served by the NER. York has its five lions, Leeds three castles, Berwick a bear and oak. What happened to poor Hull, Sunderland, Darlington, Durham, Scarborough, et al?

Who can spot the grotesque little face leering down from the main gable of the Tanner Row frontage of the building? A cut-out silhouette of a steam locomotive acts as a very fine weathervane on the Tanner Row corner. As of March 2010, the building is being converted into a luxury hotel.

North Eastern Railway War Memorial

Close to the previous building stands the NER war memorial. This was designed by Sir Edward Lutyens and was completed in 1923, although it was not officially unveiled until 1924, by which time the NER had ceased to exist. The memorial consists of a 54-foot-high

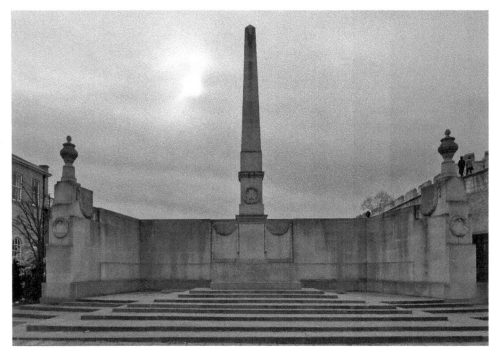

Above: The North Eastern Railway war memorial, Station Road.

Below: The observatory, Museum Gardens.

obelisk of Portland stone partly surrounded by 15-foot walls. It carries the names of 2,236 NER employees who died in the First World War. Added later were the names of those who gave their lives in the Second World War.

O

Observatory

Coyly standing in a knot of trees in the Museum Gardens is the astronomical observatory belonging to the Yorkshire Philosophical Society. It came into use in 1833 but subsequently light pollution almost totally reduced its effectiveness. The observatory is not normally open to the public.

Odeon Cinema

Standing in Blossom Street, the Odeon was opened in 1937 and is typical of the Art Deco style developed by the Odeon chain and imitated by others. Odeons were set up by the entrepreneur Oscar Deutsch in 1928. By 1941, when he died and the chain was sold to J. Arthur Rank, there were no fewer than 258 Odeons. The first Odeon in the Art Deco style opened in 1935. The architect was Harry Weedon, and Deutsch was so pleased with the result that most new cinemas in the chain were built in this style. They have been likened to the great transatlantic liners of the time. An attempt was made to render each cinema unique *and* instantly recognisable as part of the Odeon corporate brand. Deutsch called his cinemas 'palaces for the people' and not only were they striking in external appearance but

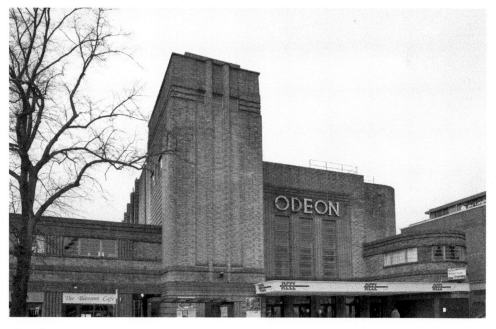

The Odeon.

they were fitted and furnished internally in a luxurious style that contrasted sharply with the drab homes in which many people lived in the interwar years. When a British film was being shown, the Union Flag flew from the top of the flagpole that surmounted every Odeon.

The tale was told that the name 'Odeon' was derived from 'Oscar Deutsch Entertains Our Nation'. This was untrue. An odeon was a Greek amphitheatre.

Old White Swan

This pub in Goodramgate is housed in an old complex of buildings which has undergone many changes of use as well as extensive rebuilds over the years. A mounting block can be seen near the entrance and this suggests that the pub may have been a coaching inn during the eighteenth century and the first half of the nineteenth century.

Ouse Bridge

The oldest of York's present-day bridges was built between 1810 and 1820. It had predecessors on roughly the same site, and they had a somewhat chequered history. One of them collapsed in 1154 and large numbers of people fell into the river but, miraculously, or so it was believed at the time, no one was drowned. A thirteenth-century bridge, like London Bridge, had buildings on each side of the carriageway. They included a court house, a wretched prison, and most notably of all, the first public pissoir in England. This facility became available in 1367, complete with an attendant. In 1564 the bridge collapsed in a flood. Its replacement was designed to allow commercial shipping to pass underneath. This bridge was demolished in 1810.

Mounting block, Old White Swan, Goodramgate.

P

Pavement
The curious name of this street linking Stonebow to Parliament Street in the city centre may be a reference to the fact that it was paved, which was unusual in medieval times. Its central position meant that here proclamations were frequently made and punishments and executions carried out. Thomas Percy, Earl of Northumberland, led an abortive Catholic uprising against Elizabeth I for which he was executed in Pavement in 1572. In 1660, when it was deemed safe to do so in the euphoria surrounding the restoration of the monarchy, an effigy of Oliver Cromwell was hanged at this point.

Phoenix
This currently closed pub (it has now reopened) is close to Fishergate Bar. For much of its existence, this hostelry was called the Labour in Vain. The origin of this curious name seems to have been in the idea that any nearby pub that attempted to brew such good beer would be wasting its time. The sign on this pub and those of a few others elsewhere definitely fell into the politically incorrect category, because they showed a white woman vigorously scrubbing a black infant standing in a bathtub. The racism implicit in such a sign was compounded in the slogan appended to one such sign outside a pub in Staffordshire, which displayed this verse: 'Washing here can now be seen / She scrubs both left and right /Although she'll get him middling clean / She'll never get him white.' The salacious-minded have taken this a step further and suggested that the woman in the sign is vainly trying to cover up the result of a sexual liaison with a black partner.

Q

Queen's Staith
This is the area on the south side of the river just downstream from the Ouse Bridge. Queen's Staith and King's Staith, on the opposite side of the river, were focal points in York's days as an important river port. More evidence of this riparian commercial activity can be seen in the buildings on the south side of the Ouse than in those on the north bank.

R

Railway Stations
York has had three railway stations. The first of these was only intended to be temporary and was located in Queen Street, close to the city walls. It opened in 1839, was timber-built, and by all accounts was a ramshackle affair. A permanent station to replace it was built in Tanner Row and it opened for business in 1841. This was built on property owned by Lady Hewley's Charity. It was jointly operated by the York & North Midland and the Great North of England railway companies. To reach this station, two openings had to be made through

Above: East side of the original York station, Tanner Row.

Left: A 'Gothic' arch in the city walls.

the city walls, a piece of vandalism that would not be tolerated today. To mollify those of an antiquarian bent, the openings were given something like a Tudor arches, which the city council apparently accepted with little demur. The first provided access to the passenger station, the second led to a small goods depot that was always known as the 'Sack Warehouse'. The openings can still be seen today.

The Tanner Row station was a substantial one and the frontage and forecourt can still be seen from Toft Green. It was designed by the talented York architect George Townsend Andrews and was built by Robert Stephenson. It bore considerable similarity to the station at Euston Square in London, which Stephenson had built earlier as the terminus of the London & Birmingham Railway. The former Royal Station Hotel can also be seen. It opened in 1853 and, like the remaining buildings of the second station, it has been used as offices for many years. This hotel is thought to be the first built as an accompaniment to a railway station. Additional platforms known as the 'Scarborough Bays' were built outside the main part of the station. The line passed beyond the Scarborough Bays to a coal depot and wharf close to the river in Tanner's Moat. This was at the bottom of an incline and in 1871 some coal trucks failed to stop at the bottom and tumbled into the river. Shortly afterwards, these sidings were taken out of use.

As more lines were built and traffic developed, this station proved increasingly unable to handle all the traffic. Not the least of the problems was that the station faced the wrong way for many of the trains – particularly those heading towards Darlington and Newcastle and in the Scarborough and Harrogate directions. This meant awkward and time-consuming manoeuvres when the trains entered and left the station. Although the station closed for

The south end of the train shed, York station.

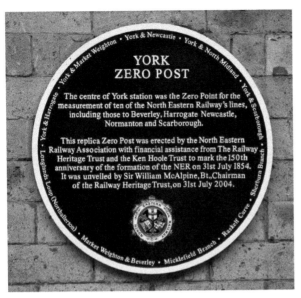

Left: The Zero Post plaque, York Station.

Below: A tiled map of the North Eastern Railway, York station.

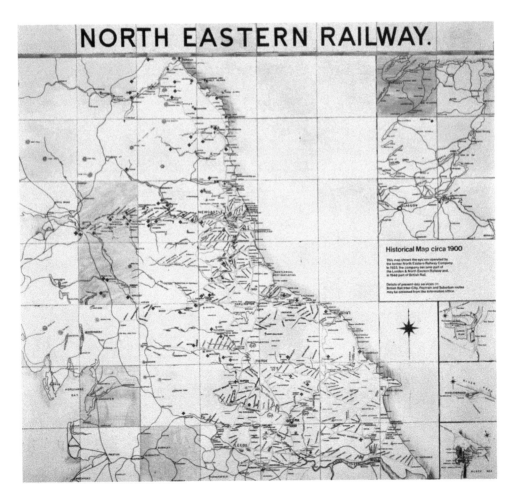

public use, carriages and other rolling stock were kept there until about 1967 when all the tracks were removed and Hudson House, a humdrum office block, was built on part of the site.

In 1877 the present through station was opened and a new Royal Station Hotel was brought into use. Like the station, it was considerably larger than its predecessor. The original designs for the station were prepared by Thomas Prosser, the North Eastern Railway's architect from 1854 to 1874, with contributions from Benjamin Burley and William Peachey. Although the exterior is not particularly notable, the interior is simply breathtaking. The iron and glass train sheds, which are 800 feet long, are a triumph of Victorian engineering with an exceptional beauty of line and proportion. The Corinthian iron columns are solid, with openwork spandrels. The attractiveness of the train shed is emphasised by the sinuous, almost sensuous curve required of the site chosen by the North Eastern Railway for this, one of Britain's finest stations. The station hotel now goes by the name of the Royal York Hotel.

Red Devil

In medieval times the streets of Britain's towns displayed large numbers of pub signs and trade signs. Houses were unnumbered and the bulk of the population was illiterate, so traders had to find a way of promoting their businesses with easily distinguishable and eye-catching signs, symbols or other devices. Sometimes there were so many that they caused confusion, and many accidents were caused when signs fell into the street or riders on horseback hit their heads on them. They gradually went out of use with the tendency to number houses and the slow spread of at least basic literacy. In the 1760s the Government

The red devil, Stonegate.

decreed that no more should be erected. They rapidly went out of use and only a few traders continued to display such advertisements. These included the barber's pole with its bloodied bandage, the three brass balls of the pawnbroker, and the pestle and mortar of the chemist. A few new signs were put up, but they were almost always restricted to the three trades mentioned. Some older signs survived. At No. 33 Stonegate, a 'printer's devil' sign can be seen. This was the traditional sign of a printer's business. A printer's devil was an errand boy or junior assistant in a printing office. One of the jobs the junior had to do involved taking the printed sheets from the press. This was dirty work and the lad might get very black – 'devil' is therefore a comment on his appearance. Alternatively, sometimes a printer's devil was a jinx that affected the work of the compositor and led to misprints and other irritating mistakes.

Red Lion

This pub stands close to Piccadilly and Walmgate. It is clearly an ancient timber-framed building but may only have been a pub since around 1800. It contains what is thought to be a priest hole. The sixteenth century was a period of great religious bigotry and intolerance. In 1534 Henry VIII inaugurated the Oath of Supremacy. This was repealed by Mary I but it was reintroduced in 1559 by Elizabeth I. She declared herself Supreme Governor of the Church of England and required anyone aspiring to public or ecclesiastical office to swear allegiance to the monarch as head of both church and state. Roman Catholics were forbidden to practise their rituals; if they did, they risked forfeiture, imprisonment or death.

Those Catholics who refused to comply were termed 'recusants' and rendered themselves liable for prosecution for high treason. Some of those who would not abjure their beliefs and practices built secret rooms or cells in their houses where Mass was celebrated and where priests, vestments and sacred vessels could be secreted. Many of these hidey-holes were constructed with extraordinary ingenuity by a Jesuit builder called Nicholas Owen. Indeed, they needed to be ingenious in order to thwart the efforts of the 'pursuivants', or priest hunters, who were basically paid by results. These men would take measurements, sound walls, demolish parts of the building or even drop burning items down chimneys in their attempts to locate hiding places. Failing that, they would sometimes listen for days, until, for example, the suspected fugitives needed to answer the call of nature. It was not unknown for fugitives to die of starvation because the occupants of the house dared not try to contact them when the pursuivant and his men were in the house.

York was something of a centre of recusancy. One of the custodians of York Castle was believed to be harbouring a Catholic priest in a part now long since demolished. This is how it was described at the time:

> In the house of Mr Fletcher the keeper they found a secret passage, sufficient for a man to pass ... they broke open several places, including the ceiling over the outgate and in the new chamber above. They searched for three days. They broke and beat down walls, ceilings, floors, hearths, boards, yea they untiled the house and breaking down all within the chambers, tossed and trod under their feet our clothes and bedding; lime, plaster, dust and dirt falling upon it. They found a great store of books and church stuff. A great spite

they had about chimneys and kept much ado about them, climbing up to the tops cast down stones to see whether there were any false ones.

Red Tower

This defensive tower of brick is part of the city walls where they run alongside Foss Islands Road. Built in 1400 or 1490 according to some accounts, it was damaged during the Siege of York in 1644 and became largely derelict. It later served as a manufactory of gunpowder, which earned it the nickname 'Brimstone House'. It took on its present appearance in 1858 when it was rebuilt. It is the only brick building in York's entire mural system.

Robin Hood's Tower

This tower is to be found on the city walls between Bootham Bar and Monk Bar. The current tower is an 1899 replacement for an older tower, which had various names over the years. It seems to have become known as Robin Hood's Tower early in the seventeenth century. It is unclear why it has this name, just as it is equally unclear why there are so many other buildings and topographical features across the United Kingdom that bear Robin Hood's name.

The authors subscribe to the view that Robin Hood is more of a concept than an actual person from history. The idea of the highborn man wrongfully deprived of his estates and expectations who defies the authorities by robbing them and then endears himself to the ordinary folk by disbursing what he steals to the poor is a common one, found not just in Britain. Perhaps Robin is a symbol of the courageous individual prepared to cock a snook at, and then completely outwit, corrupt authority. Maybe he symbolises a sense of rebellion against the exploitation and injustice that has been the lot of the poor and powerless throughout history. Rebels of this sort, real or fictional, often feature as popular heroes in folklore.

Roman Bath

This pub in St Sampson's Square probably started trading in the 1780s. During a thorough rebuilding in 1930, some baths dating back to Roman times were discovered and the name was changed to reflect this happy chance. They are open to public viewing. The pub is the only pub with this name. At one time there was a 'Roman Ruin' pub in Lincoln that had what at least purported to be a genuine Roman arch in the downstairs bar.

Roman Column

This curiosity is thought to be a fourth-century column from Roman York. It stands, looking slightly woebegone, near the south transept of the Minster. It was unearthed in 1969 during excavations under the central tower of the Minster and was erected in its current position in 1971 as part of the celebration of York's founding 1,900 years earlier.

Rougier Street

This is a fairly undistinguished short street joining Station Road and Tanner Row. Its curious name recalls Joseph Rougier, who in the nineteenth century established a workshop processing horn into jewellery and combs. Rougier was the descendant of French Huguenot immigrants.

Above: The gates at the south end of Rowntree Park.

Below: The headstone of Turpin's grave.

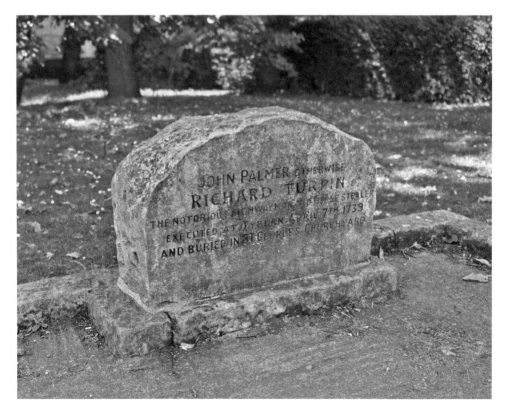

Rowntree Park
This park stands on the west side of the Ouse between the Clementhorpe district and the Millennium Bridge. It is a memorial to those employees of Rowntree's who died or were wounded in the First World War.

S

St George's Churchyard
The original church on this site in George Street off Walmgate was destroyed during the Siege of York in 1644. It was known as St George of the Beanhills. A Catholic church also dedicated to St George was built on the site and was ready for worship in 1850. It was designed by J. A. Hansom and was intended to cater for the large influx of Irish Catholics who were settling in the city at that time. Dick Turpin's headstone and grave can be found in the burial ground of the original St George's church across the road.

St Helen's
This small church, which long ago lost its churchyard, stands close to the Mansion House in St Helen's Square. The west tower has an open octagonal top stage that bears a considerable resemblance to that of All Saints, Pavement, although not on such a grand scale. Although we do not often point to items of interest inside the city's buildings, St Helen's contains an item to be relished by seekers after the curious. A plaque in the south aisle commemorates two unmarried sisters called Barbara and Elizabeth Davyyes. Remarkably, they both lived for ninety-eight years, during which time seven monarchs occupied the throne (more correctly, eight, counting William and Mary as two). Barbara was born in 1667 and died in 1765 and Elizabeth was born in 1669 and died in 1767. As if this is not enough, the memorial was paid for by their nephew, who died in St Domingo in 1797 of that Caribbean killer, yellow fever. His name, Theophilus Davyes Garancieres, is a curio itself. A memorial to him can be found in the north aisle.

St Margaret's
This small and disused church in Walmgate is a pleasant hodgepodge of architectural styles. A comprehensive rebuilding used fabric from the church it replaced, which was first mentioned in the 1180s. The brick west tower of 1684 makes a sharp contrast with the rest of the building. Perhaps most notable is the late Norman porch on the north wall, which was moved here from St Nicholas' Hospital in Hull Road. There is a fine cast-iron gateway of the early nineteenth century that was made in the nearby Walker's Foundry.

St Martin le Grand
This church stands in Coney Street. Old enough to be mentioned in Domesday, the church is a mixture of later features, much of them of the fifteenth century with heavy Victorian restorations and additions. St Martin le Grand was severely damaged in the Baedeker Raid of 1942 and was very largely rebuilt in the 1960s. The most conspicuous feature of the church has to be its clock, which protrudes from the building over the pavement. The clock

Left: The 'Little Admiral', Coney Street.

Below: The ruins of St Mary's Abbey.

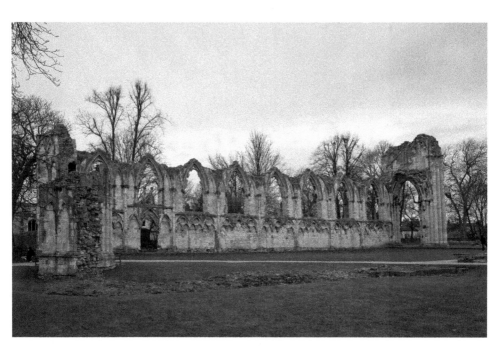

itself is thought to have originally been brought into use in 1668, but the heavy bracket of cast iron on which it stands is of the nineteenth century. The figure known as the 'Little Admiral', complete with sextant, was an addition to the original clock and was put into its present position when the bracket was set up. The clock itself is a postwar replacement.

St Mary's Abbey

In its day, St Mary's Abbey was one of the wealthiest and almost certainly one of the most magnificent monasteries in the North of England. The Benedictine establishment, although originally founded around 1055, opened on its present site in 1088, largely as a result of benefactions from William II.

A walk along Marygate leads to St Olave's church, adjoining the tower of which is the Norman gatehouse to the abbey. The visitor is then confronted with a scattered collection of ruins that even now hint at the richness of the architecture and decoration that must have been a feature of St Mary's in its heyday. Antipathy between clerics and the locals was by no means unknown, especially where monasteries were in or close to towns. Abbots were frequently high-handed and much animosity was generated when one of them, Simon de Warwick, unilaterally decided that the fairs that were held in nearby Bootham should pay the abbey a tax for the privilege. The violence that resulted led to the abbey being surrounded by walls. Defensive walls around a monastic establishment are not unique to York, but the remains that survive are more extensive than those found anywhere else. Parts of them can be seen in Bootham and Marygate. Many fragments of the abbey are displayed in the Yorkshire Museum, where it is possible to gain a good idea of the history and the architecture of St Mary's.

The easiest remnants to recognise are those of the north and west walls of the chancel of the church, which would have been the centre of a complex collection of monastic buildings. Other fragments are much more difficult for the layman to interpret. As so often happened with dissolved monastic establishments, the lead was quickly stripped off the roofs and the buildings decayed and were pillaged indiscriminately and used as a quarry for new buildings being erected in the neighbourhood.

St Mary Bishophill Junior

In its west tower, this small church displays the oldest ecclesiastical architecture in York. The tower shows that Roman masonry was plundered and incorporated into the building, which, at least as far as the base is concerned, is of the tenth century.

St Mary's Tower

This round tower at the junction of Bootham and Marygate was built around 1325 as part of the abbey. In 1644 it was severely damaged when it was blown up by Parliamentary troops. It was rebuilt, but evidence of the damage can still be seen.

St Peter's School

Founded in AD 627, St Peter's is one of the oldest schools in England, and is arguably the third oldest school in the world. It has had a number of locations in York but has been based in Clifton for 175 years or more. Over the years its alumni have scattered to the four

The tower of St Mary Bishophill Junior.

corners of the globe and doubtless made their contributions. One website, however, under the heading of 'Alumni', mentions only Guy Fawkes.

St William's College
Put up between 1465 and 1467 on the site of an earlier prebendal building, St William's College housed the chantry priests attached to the Minster. Chantries were abolished in the English Reformation and since that time the college has seen a variety of uses. It has contained private dwellings, a printing works, and shops. It is now one of York's many tourist attractions.

Shambles
Appearing on a thousand and one calendars of 'Picturesque England' and photographed more than a million times a year, Shambles (people usually prefix it with the definite article) is almost certainly York's best-known street. Its name indicates that it was the place where the butchers plied their wares from benches or 'shambels' outside their premises. It is short, narrow, cobbled and curved, and its most memorable feature is probably the way that some of its jettied or oversailing buildings jut out across the street sufficiently far to have allowed residents with extremely long arms to shake hands with their neighbours on the opposite side of the street, a notion that children find particularly intriguing. A few shops retain the wide wooden sills that were used in the days when customers were served from the open windows on the ground floor of the premises.

The Shambles is a tourist honeypot, over-restored and sanitised and, as such, almost entirely robbed of any atmosphere. The buildings themselves mostly date from the

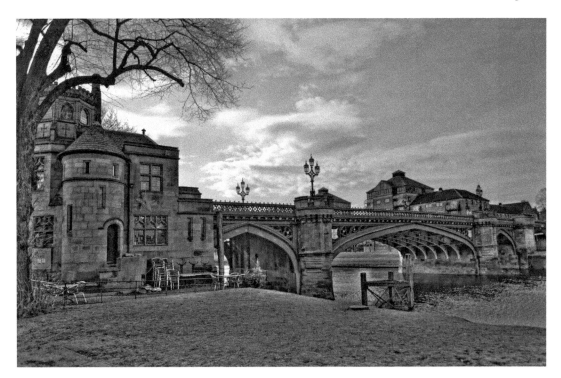

Skeldergate Bridge, looking south.

fifteenth, sixteenth and seventeenth centuries, although they have all been heavily restored. Two cheers for the Shambles?

Skeldergate Bridge
This bridge was the last of the three built across the Ouse in central York. Replacing a ferry, it opened for business in 1881 and was a toll bridge until 1914. Some confusion accompanied its construction because it seemed that the need for it to be able to open to allow shipping through had been overlooked. Therefore the bridge as built was considerably different to the bridge originally planned. It can no longer be opened.

Snickleway Inn
An ancient building in Goodramgate long in use as a pub but reputed to have once been a brothel, the Snickleway Inn has had many names over the years and its present one is unique. It claims to have more ghosts than any other pub in York.

Statue of Minerva
Over a shopfront at the corner of Minster Gates and High Petergate stands a statue of Minerva. Minerva was the Roman goddess of wisdom as well as the patroness of the arts and trades. According to mythology, she was born when, brandishing a sword and whooping a battle cry, she emerged fully-formed from the brain of Jupiter. She is normally represented as being grave and majestic, clad in a helmet and with drapery over a coat

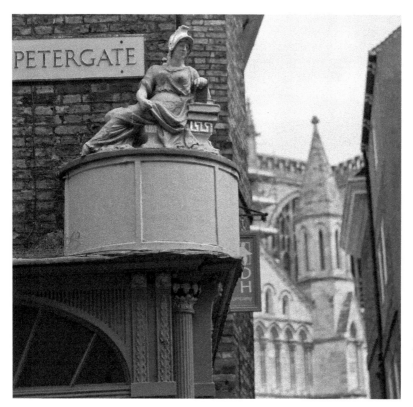

Minerva, at the junction of the Minster Gates and High Petergate.

of mail. Her presence in York as a shop sign drew attention to what was a bookseller's premises. Minerva's supposed erudition made her a suitable advertisement for such places.

Street Names

York is rich in curious street names. Many of them are not what they might appear to be at first sight. The city has more street names ending with 'gate' than anywhere else in Britain. This does not necessarily mean that the street runs to and from a gate. Gate in this case is derived from 'gata', a word of Scandinavian origin meaning 'street', and is evidence of the substantial settlement in and around York of people who came from that part of the world.

Ascribing the origin to street names is not a precise science. A selection of quirky names follows but the authors are not claiming a monopoly on the truth.

- The delightfully named Blossom Street had previous incarnations as Ployhsuaingate and Ploxswaingate. It means 'the ploughman's street' and we should be thankful that we don't have to try to get our tongues around either of its earlier names.
- Bootham means a settlement or 'ham' of small huts or 'booths'.
- Brownie Dyke is a staith on the River Foss close to Castle Mills Bridge and is a derivation of 'brun eau dyke', by which the Anglo-Normans referred to the muddy brown river.

- Church Street is a mundane name indicating the presence of a church, in this case St Sampson's, but much more interestingly it used to be called 'Girdlergate' – the street of the girdle-makers.
- Colliergate has little to do with miners but was at one time associated with either charcoal burners or sellers.
- Coppergate was the street of the carpenters and comes from an Old English word meaning a turner or joiner.
- Davygate is named after a man whose first name was David and who was the king's lardiner in the twelfth century. A lardiner was charged with the responsibility of supplying game for the royal table. This also required him to be a kind of super gamekeeper, enforcing the law in the royal forest of Galtres just to the north of York.
- Fetter Lane was a street occupied by felt workers.
- Finkle Street was known as 'Fynkullstrete' in 1370 and probably took its name from someone called Finnkell. Later this became the wonderful 'Mucky Pig Lane' because a pig market was held in the area. The great and the good of Victorian York felt that such a name was not consonant with the dignity expected of a street in the city centre and it reverted to Finkle Street, which, while not itself a bad name, is not a patch on Mucky Pig Lane. The authors would happily spearhead a campaign for that name to be restored.
- Hornpot Lane is of Anglo-Saxon origin and was the place to find those who worked with horn.
- Hungate in the twelfth century was 'Hundegat in Mersch', which roughly translates as 'the dog's street in the marsh'. It seems that the butchers of the Shambles used to dump bones, offal and other items in the vicinity and, not surprisingly, this downmarket part of the city attracted foraging dogs in large numbers and presumably rats, flies and other scavengers. A later name was 'Dunnyngdykes', which was scarcely an improvement because it meant something like 'place where animal dung is dumped'.
- Jewbury refers to 'Jew's burh', which was the part of the city in which the Jewish population was concentrated.
- Lendal is probably derived from 'Landing Hill', referring to a staith on the Ouse belonging to the Austin Friary close by.
- Lord Mayor's Walk was a civic improvement to what was previously a rather dismal part of the city just to the north of the walls. A muddy track was widened and planted with elm trees and it quickly became a place to which the Georgian middle classes resorted – a place where they could strut up and down, seeing and being seen. Earlier, the track had been known as 'Goose Lane'.
- Micklegate was the main approach to the city from the south. It was a prestigious and prosperous part of York and 'mickle' meant 'great'.
- Ogleforth was a ford belonging to someone called 'Ugel', but nothing is known about why he merited having a ford named after him.
- Patrick Pool is a truncated street close to the market. It may refer to a church dedicated to St Patrick and the 'pool' may be the Roman bath, part of which can be seen inside the pub of that name in St Sampson's Square.
- Piccadilly was a new street created in 1840 and it was seemingly given that name for no other reason than that London already had a Piccadilly.

- Skeldergate is an odd name and it *may* be something to do with shields. Did York's shield-makers have their businesses here in days of old?
- Spurriergate certainly housed spur-makers and also lorimers, who made a variety of small metal objects.
- Walmgate seems to have an association with a former resident by the name of Walba.
- Footless Lane was near the watergate of St Leonard's Hospital and was where physically impaired mendicants gathered in order to solicit alms.

T

Theatre Royal
In St Leonard's Place, the Theatre Royal has its origin in a theatre opened on the same site in 1744, partly on the site of the former St Leonard's Hospital. From the foyer it is possible to catch a glimpse of parts of the former hospital walls. Having opened as the New Theatre, it gained its present name in 1769 and over the next thirty years or so became one of the very finest provincial theatres.

We are taking something of a liberty with our brief here, because although we are dealing with a curiosity, it is one that is unlikely to be seen from the street and one that some people would deny can be seen at all. We are referring to the ghost of the Theatre Royal. A cynic might say that it is no wonder that theatres seem to attract a disproportionate number of ghostly and supernatural stories because it could be argued that their entire raison d'être is make-believe – the willing suspension of disbelief. People who work in them and who view their productions are in an atmosphere that makes them particularly susceptible to suggestion. The theatrical world is rife with superstitions.

The ghost of the Theatre Royal is the Grey Lady. Nothing very novel about that, you might say. This apparition has been seen by large numbers of people over a long period. They have been unable to furnish a detailed description, but they seem to agree that it is dressed in a grey habit and white headdress and is the ghost of a novice nun who ministered to the poor and infirm of St Leonard's Hospital. To add a touch of pathos to the image being built up, they add that she committed some unmentionable peccadillo for which she was cursed by the Mother Superior and condemned to forever remain in the place whose sanctity she had so badly besmirched.

The Retreat
At the top of the hill on what is now Heslington Road, The Retreat was opened in 1796 at a time when the received wisdom was that there was no such thing as mental illness and that those who had behavioural problems were possessed by demons or malignant spirits. The way to cure the patients was to expel the demons. This could be done, or so it was thought, by employing various physical treatments. They included purging of the bowels, physical restraints, sudden immersion in freezing cold baths and the unexpected detonation of loud explosions. If these were not enough, the patients were abused mentally and physically and the terrors they experienced only served to exacerbate the condition of many of those who received such treatment.

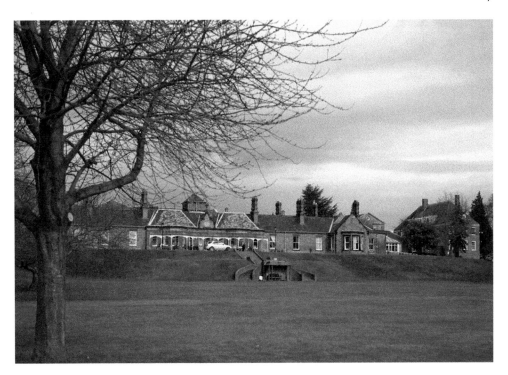

The Retreat, from Walmgate Stray.

In 1790 a Quaker woman called Hannah Mills died in the York Asylum. Friends and relations had been refused admission while she was an inmate. This was naturally a cause for concern and, after she had died, several influential Quakers pulled strings and obtained permission to investigate the way in which the 'patients' were treated. They were horrified by what they found and it was decided to raise money to build and run an asylum with a very different and much better therapeutic regime, initially only for Quakers. William Tuke (1732–1822), himself a prominent York Quaker, was put in charge of the project. Great care was taken with the design of the building and the regime was to be one in which the patients were treated with humanity in comfortable surroundings. There was to be no physical restraint and no punishment and it was believed that caring therapy would restore the self-esteem of the patients. There were workshops where they could make things and gain pride from doing so. Additionally, they could read books, wear their own clothes as opposed to institutional uniform, and wander freely around the restful grounds. Those who cared for the patients were carefully selected on the basis of their commitment to the project's aims and also their spiritual values. One important aim was to create a sense of family or community and the patients and staff lived, ate and worked very closely together.

It is perhaps only to be expected that these ideas and practices incurred much ridicule, especially when it was revealed that in spite of good intentions, restraints were still being used, if only as a last-ditch and unavoidable expedient. Violent treatment of the patients, however, was totally forbidden. It was not long before The Retreat was showing significant

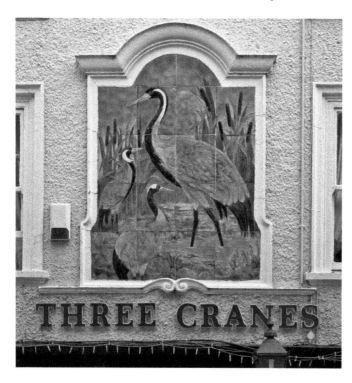

Left: The Three Cranes tiled pub sign, St Sampson's Square.

Below: The remaining wall of the Franciscan friary.

results. The most stunning one, by the standards of the time, was that patients finished their residence and went home to live their lives among family and community, something virtually unheard of in those days. Many of The Retreat's principles and practices went on to be taken up and successfully applied elsewhere. Samuel Tuke, William's grandson, coined the phrase 'moral treatment' in 1813.

It is fair to say that The Retreat has played a proud role in the history of the treatment of mental illness, combining an adherence to the best of its long-established principles with an open-minded adoption of new clinical methods and applications as they have developed. The Retreat is currently an independent hospital providing specialised services for people from across the UK and it remains very much at the cutting edge of mental healthcare, retaining the holistic approach that has always been fundamental to its practice. The treatment of most patients is funded by the NHS, which recognises the unique services that The Retreat offers.

The buildings and the grounds of The Retreat are not open to the public.

Three Cranes

A very old pub with a licence originally issued in 1749, the Three Cranes is marked out by an unusual and rather fine tiled mural sign on its façade. This depicts cranes of the avian sort, but this is probably a whimsy because it is generally believed that the cranes referred to were those used to move large items of merchandise around on the market, which used to be held in front of the pub until the 1960s – after which the space became known as St Sampson's Square.

Three-Legged Mare

Although located in an old building, this is a newish pub and is uniquely named. It refers to the gallows, which had three arms so that multiple executions could be carried out simultaneously. One such device was erected at the Knavesmire and doubtless numerous highway robbers and footpads made their acquaintance with it in the eighteenth and nineteenth centuries. A replica of the three-legged mare stands in the small garden at the rear.

Tower Place

This short and narrow street joins Tower Street to the Davy Tower, close to which is the last visible remnant of a thirteenth-century Franciscan friary. This establishment was of more than local importance because it housed the proceedings of Parliament on a number of occasions in the fourteenth century and was used as a residence by a number of kings, in particular Richard II. It was dissolved and demolished in the sixteenth century.

Treasurer's House

Situated in Minster Yard and in the shadow of the Minster itself, Treasurer's House stands on the site of the house used by the Minster's treasurers in medieval days. It ceased to be used for that purpose in 1547 and soon after it came into the hands of the Young family, who retained it until the middle of the seventeenth century. Extensive remodelling took place in the eighteenth and nineteenth centuries. In 1930 the house was gifted to the

National Trust and it is open to the public. In 1960 a plumber working on the premises was in the cellars having his sandwiches when he was shocked to see a Roman legion marching close by, apparently on their knees. A few years later excavations revealed a Roman road about 18 inches below the cellar floor and just about the right height to have made the legionaries look as if they were marching on their knees. How about that then?

Tyburn
This site has been mentioned before in connection with Dick Turpin (see page 30). Executions were carried out at the Knavesmire by the side of Tadcaster Road. One curiosity of the place is that the first and last miscreants to be executed there were both guilty of rape.

A rival to Dick Turpin as a notorious highwayman was John 'Swift Nicks' Nevison. A Yorkshireman from Pontefract, Nevison was a brutal and unscrupulous but also highly resourceful villain who majored in highway robbery but added protection rackets to his portfolio of felonies. Stories about his activities are legion. His criminal activities ranged across much of Britain south of York and even extended into Holland. He was bold and had innumerable hair-raising adventures, although, as with so many of his kind, it is difficult to establish exactly where fact ends and fiction takes over. In 1676 he was confined in York Castle on the capital charges of robbery and horse stealing, but he managed to persuade the authorities to let him enlist in a body of volunteer soldiers bound for Tangier. He was taken in chains to embark on board a vessel at Tilbury and his guards had just knocked his chains off when he jumped overboard, crawled ashore and disappeared into the neighbouring countryside.

As far as York is concerned, Nevison's significance is that it was probably he, not Turpin, who made a breakneck horse ride from London to York. He had committed a robbery at Gad's Hill in Kent. He wanted to establish an alibi by being seen in York in what seemed to be an impossibly short time after the robbery. Having completed what by any standards was a remarkable feat of horsemanship, he saw to it that he conversed with several of the city's leading citizens who would later be able to testify on his behalf that he was in York at a time so soon after the robbery that he could not possibly have done it. This clever ploy worked; however, you rarely hear about this old highwayman, and Swift Nick's luck eventually ran out. He was hanged in 1684 or 1685 according to some, but his life's activities are the sort of which legends are made. Three stanzas from a contemporary ballad give a flavour of this posthumous glorification:

> Did you ever hear tell of that hero,
> Bold Nevison that was his name?
> He rode about like a bold hero,
> And with that he gained great fame.
>
> 'Tis now before my lord judge,
> Oh! Guilty or not do you plead?
> He smiled unto the judge and the jury,
> And these were the words that he said.

'It's when that I rode on the highway,
I've always had money in store,
And whatever I took from the rich,
I freely gave to the poor.'

A likely story. The last execution at York's Tyburn was in 1801.

W

Walmgate Bar
This is the only one of York's city gates that retains its barbican. Walmgate Bar has often found itself involved in military action. It was burned in 1489 during a local uprising and was badly battered by artillery during the Siege of York in 1644. The marks of cannonballs can be seen.

The attacking forces attempted to undermine the bar and were partially successful. A slight sag in the stonework is evidence of subsidence created by sapping work (i.e. aggressive tunnelling performed by attacking soldiers) underneath the bar. The timber-framed seventeenth-century house that peeks over the top seems rather incongruous.

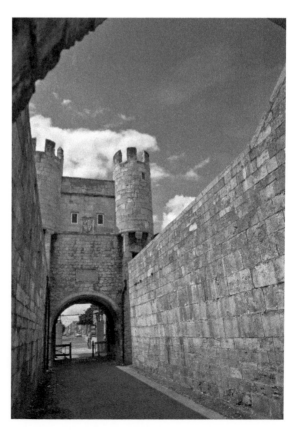

Walmgate Barbican.

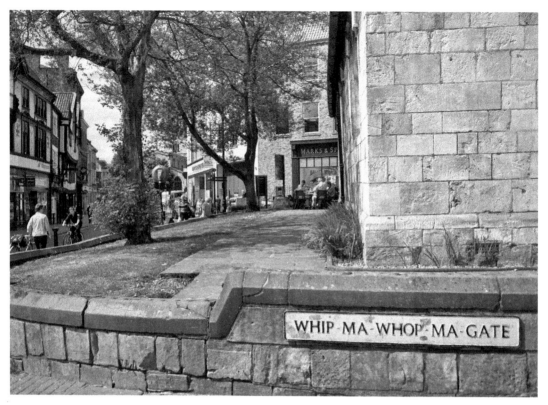

Whip-Ma-Whop-Ma-Gate

Whip-Ma-Whop-Ma-Gate
A short street with a long name. In fact it is both the shortest street in York and the street with the longest name. It is 35 yards long and it joins Colliergate to Pavement. Theories abound to explain the extraordinary name, but no one actually knows for sure. It *is* known that in 1505 it was known as 'Whitnourwhatnourgate'. Did they wallop a dog here for stealing meat from a stall in the Shambles?

Y

Ye Olde Starre Inn
Tucked away down a passage off Stonegate, this old pub has one of England's few remaining 'gallows' pub signs stretching across the street. The sign, erected in the 1730s, certainly makes an eye-catching advertisement. The exact origins of the pub are not known but it is thought to date from the 1640s. A curiosity of the pub is a verse hanging on a wall recording that a seventeenth-century landlord called Foster, an avid Royalist, refused to serve any Parliamentarians who dropped in for a pint or two after their army had successfully captured the city. In the tense atmosphere of hatred and suspicion that was such a feature of the time, this took some courage. The pub has an impressive collection of ghosts, but

The 'gallows sign' of Ye Olde Starre Inn, Stonegate.

the most unusual are those of two cats supposedly bricked up alive near the door – a not uncommon practice that, as the sacrifice of a living creature, was supposed to bring good luck to the premises and safeguard them. Whether or not it did, who is to say? The practice certainly brought bad luck to the cats. The presence of these ghostly felines is known to have spooked several dogs brought onto the premises.

York Brewery
Like many cities of its size, York formerly had a number of brewers. Several of these were individual publicans licensed to brew and sell ale and beer on their own premises. A few examples were the Black Horse, Monkgate; the Golden Lion, St Sampson's Square; the Packhorse Inn, Skeldergate; and the Saddle Inn, The Mount. There were one or two companies who brewed mainly to supply the tied houses that they owned. The largest of these was John J. Hunt of Aldwark, taken over by Cameron & Co. in 1953. Brewing ceased in 1956 and demolition of the plant occurred in 1972. There was also a brewery in New Lane, Huntington, called the Yorkshire Clubs Brewery, which had moved to York from Pocklington in 1933. Working men's clubs and institutes flourished, particularly in the North of England, and the Yorkshire Clubs Brewery was one of a few such businesses that developed to supply these clubs with cheap beer and provide an alternative to the mainstream commercial breweries, which often contributed some of their profits to the coffers of the Conservative Party.

The York Brewery is based at Toft Green and started operations in 1996. It owns four pubs in the city but also has a public bar on the brewery premises. Highly recommended.

York Dungeon

The attraction of the macabre, the gruesome, the sinister and the scary is unquestionable, just so long as it poses no real threat. The York Dungeon 'experience' concentrates, in a safely controlled way, on a carefully selected number of events and occasions from the city's turbulent past. Is it history? Is it heritage? Does it matter? It's fun.

York Minster East Window

The authors have deliberately said very little about the Minster because others do a much better job. It is such a huge and immensely complex building. It is the largest church in the so-called Gothic style in Britain, if, as it should be, Liverpool Anglican Cathedral is excluded. One feature that is easy to identify and examine when perambulating in the vicinity of the Minster is its east window. The glass of York Minster is a treasured survivor of exceptionally high quality by English standards. Ancient painted glass is singularly vulnerable to vandalism, to excesses of misdirected religious zeal, to the ravages of time, to incompetent restoration, and to fires, of which the Minster has certainly had more than its fair share. The east window is huge. It has often been referred to as 'a window as big as a tennis court'. At 78 feet by 36 feet and consisting of nine lights, it is the largest in the United Kingdom with the exception of that at Carlisle Cathedral. It was designed around 1400–5 by Hugh Hedon. It is not unfair to the rest of the building to say that the Minster's great glory is its windows, in which the development of English glass-painting can be followed through at least three centuries. No other great English church has preserved so much of its original glazing.

Afterword

Winchester was, London is, and York shall be, the finest of the three.
—Mother Shipton, soothsayer of Knaresborough

John Taylor, the eccentric waterman and part-time poet, made the journey from London to York by boat in 1622. He arrived at the King's Staith on the Ouse. He stayed at the George in Coney Street, a famous coaching inn long since demolished, and it is clear that he admired York. This is what he said:

> The city oft hath known the chance of wars,
> Of cruel foreign and of homebred jars.
> 'Tis large, 'tis pleasant, and magnificent,
> The North's most famous fertile ornament.
> 'Tis rich and populous, and hath indeed
> No want of anything to serve their need.
> Abundance doth that noble city make,
> Much abler to bestow, than need to take.

We are not sure about the quality of the verse, but we like the sentiments expressed, so on that note we will bid our readers, if any, a grateful adieu.

About the Authors

Ed Brandon grew up in Peterborough. He gained a passion for photography while travelling extensively around the world from 2005 onwards. Having contributed photographic work to a number of books and magazines, he is currently researching, photographing and writing for his first solo book, *Madhouse: A Social History of British Asylums and Mental Hospitals*. Examples of his work can be found on his website – which can be found at *www.anotherstateofmind.zenfolio.com* – as well as on his popular Facebook photography page, 'Another State of Mind Urban Exploration'.

David, Ed's father, has around thirty published titles to his name. His main interests are topographical oddities and curiosities, social history, railways, and the history of London.